LOOKING TOGETHER

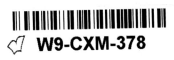

EDITED BY

REBECCA BROWN

MARY JANE KNECHT

LOOKING TOGETHER

WRITERS ON ART

FRYE ART MUSEUM

SEATTLE

IN ASSOCIATION WITH

UNIVERSITY OF WASHINGTON PRESS

SEATTLE AND LONDON

University of Washington Press
PO Box 50096, Seattle, WA 98145
www.washington.edu/uwpress

Frye Art Museum
704 Terry Avenue, Seattle, WA 98104
www.fryemuseum.org

The paper used in this publication meets the
minimum requirements of American National
Standard for Information Sciences — Permanence
of Paper for Printed Library Materials, ANSI
Z39.48-1984.

LIBRARY OF CONGRESS
CATALOGING-IN-PUBLICATION DATA

Looking together : writers on art / edited by
Rebecca Brown and Mary Jane Knecht. — 1st ed.
 p. cm.
ISBN 978-0-295-98882-5 (pbk. : alk. paper)
1. Art—Literary collections. 2. American
literature—21st century. I. Brown, Rebecca, 1956–
II. Knecht, Mary Jane. III. Charles and Emma
Frye Art Museum.
PS509.A76L66 2009 810.8'0357—dc22
2008048493

ILLUSTRATION DETAILS: Sandström, p. 2;
Van Veen, p. 29; Von Max, p. 51; Cole, p. 79;
Bierstadt, p. 86; Twachtman, p. 88; Robleto, p. 94
ADDITIONAL ILLUSTRATIONS: Piccinini, p. 45;
O'Neil, p. 59; Darger, p. 70-71

CONTENTS

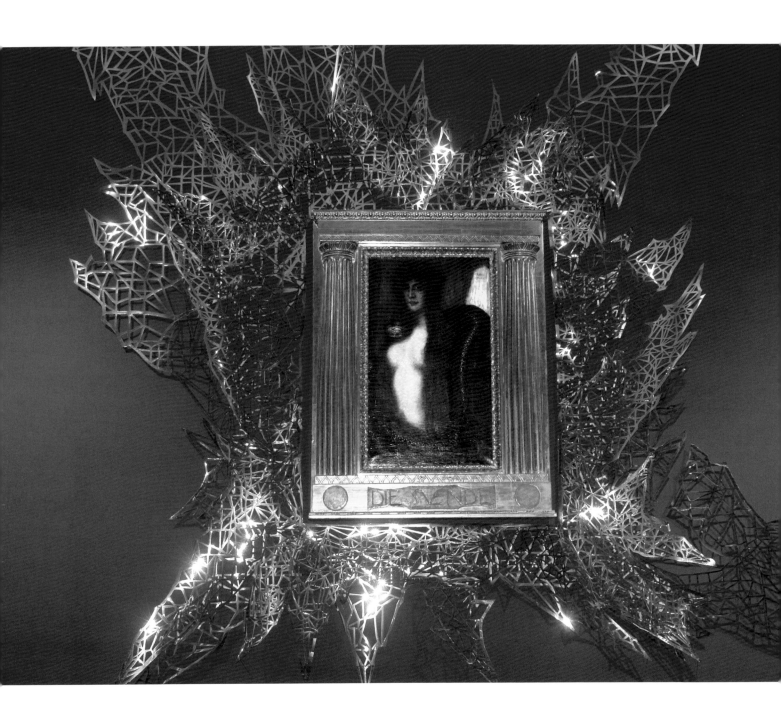

Franz von Stuck. *Sin (Die Sünde)*, c. 1908. Syntonos on canvas. Charles and Emma Frye
Collection. Victoria Haven. Altar for *Sin*, 2007. Mylar, polypropylene paper, and pins.
Courtesy of the artist and Greg Kucera Gallery, Seattle. Photo: Paul Macapia.

FOREWORD

Looking Together: Writers on Art — commissioned responses from a variety of perspectives by some of the Northwest's best writers to paintings, drawings, and sculpture recently exhibited at the Frye Art Museum — is exemplary of the museum's efforts to make deep and lasting connections between audiences and individual artworks in the museum's collections and special exhibitions. More importantly, *Looking Together* is a demonstration of the museum's commitment to interdisciplinary artistic inquiry in its exhibitions, programs, and publications, one important way we honor and extend the legacy of Frye Art Museum founders Charles and Emma Frye.

When the Fryes first made that important leap from being art viewers to art collectors in the 1890s, they forged close working relationships with a select group of artist-advisors. The tastes, knowledge, and viewing habits of painters Henry Raschen, Eustace Paul Ziegler, and Pieter van Veen remained important to the couple during the next twenty-five years as they built a private collection of nineteenth-century European art and dreamed of gifting it to the city of Seattle after their deaths. Ziegler remained an important advisor to founding director Walser Greathouse even after the Charles and Emma Frye Free Public Art Museum opened its doors to the public in 1952.

In the Fryes' First Hill home, where their growing art collection was housed in a special annex and was made available for viewing to special guests, artists were invited from a range of disciplines to do their creative work in the galleries the collectors had created. Musical concerts and poetry readings were sponsored by the Fryes in their private gallery when there was not yet a public venue for such cultural events in Seattle.

Creators — whether artists, writers, scholars, scientists — are often those we seek out to challenge our perspectives, provide new insights, and enrich our understanding of our world. In the early months of my tenure at the Frye, I began researching the Frye Founding Collection and familiarizing myself with its individual works of art. In this effort I met often with artist friends, walking with them through the Frye galleries and looking at paintings. Closely observing art arm-in-arm with someone who makes art, and sharing thoughts on technique, subject matter, and art history along with bigger questions of art's relevance, value, and shifting nature — after all, art is a category we humans create and fill with meaning — is among the most satisfying of viewing experiences.

From this pleasure of looking and thinking together came the impetus for Fly on the Wall, an occasional series of interventions into existing exhibitions in which artists were invited to write interpretive wall labels for selected works in the Frye Collections. My desire was that you, whether a first-time visitor or a longtime devotee of the Frye, might discover or rediscover your favorite paintings through the eyes of artists, writers, film critics, and others, whose written comments accompanied their selections. Fly on the Wall contributions were often performed by artists whose work was on view elsewhere in the museum, providing links between an artist's current practice and his or her own thoughts on historical art.

In 2005, the Frye Board of Trustees resolved that the Founding Collection could for the first time be exhibited together with other artwork. This landmark decision has allowed us to involve artists and other creators much more deeply, making this collection a true catalyst and rich store for artistic inquiry. Some examples for your consideration:

The exhibition Sin (2007) paired an important work from the Frye Founding Collection, Franz von Stuck's *Sin* (*Die Sünde*; c. 1908), with a contemporary artwork. The Frye commissioned artist Victoria Haven to create a new altar for *Sin*. The exhibition

was a meditation solely on this coupling of artworks. Although *Sin* is typically installed as a modern work, hung at eye level, the artist intended the painting as the key feature of an altar, placed far above spectators' heads. This placement significantly alters the relationship between *Sin* and its viewers. Haven's delicate but dramatic sculpture, constructed of gold Mylar and pins, complemented and enhanced *Sin*'s compelling and dangerous sexual persona.

Sigrid Sandström's paintings, sculpture, and projected works were featured at the Frye in Ginnungagap: Recent Art by Sigrid Sandström (2006), her first solo museum exhibition. She also selected from the Founding Collection dark, melancholy landscapes for the exhibition Oyster Skies: Meditations on Northern Landscapes (upcoming), in which the paintings will be exhibited with a recent projected work by Sandström.

The most recent and ambitious exhibitions of this initiative are Dreaming the Emerald City: The Collections of Charles and Emma Frye and Horace C. Henry (2007–08), which united for the first time the founding collections of the Frye Art Museum and the Henry Art Gallery at the University of Washington, and Heaven Is Being a Memory to Others (2008), the result of a 2007 residency by artist Dario Robleto and his research in the Frye Founding Collection.

The exhibition Heaven grew from Robleto's fascination with what we don't know about Emma Lamp Frye, which engaged his longstanding obsession with manifestations of longing, loss, memory, and our desire for immortality. The exhibition imagines Emma in her multiple possible roles: lover, bride, wife, thwarted mother, music lover, art collector, hostess, and civic benefactress. Especially for this exhibition, Robleto created several new sculptures to be displayed with works selected by the artist from the Founding Collection.

Looking Together: Writers on Art is a publication and reading series deeply aligned with these curatorial ventures, all created with the goal of providing new contexts and expanding audiences for Frye Art Museum exhibitions and collections. What is special about this volume is that it lives beyond any single encounter with a work of art or the experience of a single exhibition. I desire to see a dog-eared copy of this book in the hands of a Frye Art Museum visitor twenty years from now, when he or she is looking at Founding Collection paintings accompanied by selections from this compendium. My thanks to co-editors Mary Jane Knecht, Frye Art Museum manager of adult programs and publications, and writer Rebecca Brown. They superbly selected the writers and sensitively paired them with works of art in the Frye Collections and special exhibitions. Their close collaboration and dedication to this project have made this publication possible.

ROBIN HELD
Chief Curator and Director of Collections and Exhibitions, Frye Art Museum

In the spring of 1903, a twenty-nine-year-old medical school dropout named Gertrude Stein ran away to Paris. She joined her brother Leo, who, courtesy of family money, was looking at art and painting. Gertrude was happy to look at art with her brother, but what she really wanted to do was write. She had, in fact, after spending 1902 reading all the English novels she could get her hands on at the British Museum, begun to write a novel of her own. Though unpublished in her lifetime, *Q.E.D.* is now part of the prestigious Library of America series (Melville, Hawthorne, Dickinson, Philip K. Dick, and so on). Here's a passage from *Q.E.D.*:

> The last month of Adele's life in Baltimore had been such a succession of wearing experiences that she rather regretted that she was not to have the steamer all to herself. It was very easy to think of the rest of the passengers as mere wooden objects; they were all sure to be of some abjectly familiar type that one knew so well that there would be no need of recognizing their existence.[1]

Though the content of the book is radical for the era (it tells the story, thinly disguised, of Stein's aborted lesbian love affair with a girl named May Bookstaver), the prose is straight-ahead late nineteenth-, early twentieth-century literary English, hardly the kind of thing to get you into the Library of America.

There *is* something interesting, if somewhat creepy, going on with that business about the passengers being "mere wooden objects," but of course Stein, before she had dropped out of Johns Hopkins, had been studying in the then-new field of psychology and, under the tutelage of men like William James, had become convinced that every individual human being is a "type," "abjectly familiar" or not. Stein decided that the kinds of characters she created — in writing

and in life — would somehow incorporate these new ideas about the human psyche. But how could she do that within the traditional framework of the novels she had studied?

Two years after settling in Paris, Stein began a new book, *Three Lives*. Here's a passage from the "life" of "Melanctha":

> It would never come to Melanctha to ask Rose to let her. It never could come to Melanctha to think that Rose would ask her. It would never ever come to Melanctha to want it, if Rose should ask her, but Melanctha would have done it for the safety she always felt when she was near her. Melanctha Herbert wanted badly to be safe now, but this living with her, that, Rose would never give her. Rose had strong the sense for decent comfort, Rose had strong the sense for proper conduct, Rose had strong the sense to get straight always what she wanted, and she always knew what was the best thing she needed and always Rose got what she wanted.[2]

While some of the content in this passage may seem familiar — Stein is still writing partly about the power dynamics of the May Bookstaver affair — the prose, well, the prose is something very else indeed.

What happened to Stein between 1903 and 1905 that allowed her to throw off the Victorian literary models she had inherited and begin to compose in the radical new style more suited to her very modern ideas about character and perception? In a word: Cézanne.

Leo Stein bought his first Cézanne landscape in the spring of 1904. Informed by his friend Bernard Berenson that there were a lot of Cézannes in the collection of a wealthy American in Florence, Leo left for Italy. After Gertrude joined him there, the siblings embarked upon what Leo later called a "Cézanne

debauch."[3] By 1905 Leo and Gertrude were buying the work of Cézanne, and of many other artists, together. As they increased their activities as collectors, Leo stopped painting. Gertrude, however, wrote even more. And the more she wrote, the more what she wrote became shaped by what she looked at. In this passage from *The Autobiography of Alice B. Toklas*, Stein describes, in the voice of her life partner Alice B. Toklas, what happened after the Steins bought their first portrait by Cézanne:

> It was an important purchase because in looking and looking at this picture Gertrude Stein wrote Three Lives.
>
> She had begun not long before as an exercise in literature to translate Flaubert's Trois Contes and then she had this Cézanne and she looked at it and under its stimulus she wrote Three Lives.[4]

Flaubert's *Three Tales* gave Stein a shape for a book of portraits as well as encouragement to write about the kinds of characters — overtly sexual, obsessed — that had not previously appeared in American letters. Flaubert also modeled ways to write about characters who were truly pure, as opposed to merely Puritan. But it was through looking at Cézanne that Stein began to develop her singular sentences. In a 1946 interview, Stein elaborated on what she learned from Cézanne:

> Cézanne. . . gave me a new feeling about composition. Up to that time composition had consisted of a central idea, to which everything else was an accompaniment and separate but was not an end in itself, and Cézanne conceived the idea that in composition one thing was as important as another thing. Each part is as important as the whole, and that impressed me enormously, and it impressed me so much that I began to write Three Lives. . . I was more interested in composition at that moment. . . I was obsessed by this idea of composition, and. . . Melanctha was a quintessence of it. . . .

> I tried to convey the idea of each part of the composition being as important as the whole. . . . The realism of the people who did realism before was a realism of trying to make people real. I was not interested in making the people real but in the essence or, as a painter would call it, value. . . . This was an entirely new idea. . . I got it from Cézanne.[5]

When she looked at Cézanne, Stein saw that the phrases in sentences, like the blocks of color on a canvas, were, aside from or in addition to any meaning they might have in any representative sense, objects in their own right. Stein also saw that the arrangements of these words/objects created entirely new meanings. In *Three Lives*, published in 1909, readers began to see the insistently repetitive, musically rhythmic prose now associated with the writer the Library of America called "The Most Creative and Radical Innovator in 20th Century."[6]

Stein's canonization was hard won. For decades, many in the mainstream literary establishment dismissed Stein as an idiot, unreadable, a huckster or a fool. She wasn't. Once Gertrude Stein figured out that she wanted to recreate literature, she knew exactly how and where and with whom to do it. As she recalled in *Paris France*, of 1940, "Paris was the place that suited those of us that were to create the twentieth-century art and literature, naturally enough."[7]

Whether you agree with Stein's assessments about the histories of painting and literature, you have to acknowledge that she believed the paintings of Cézanne were important to her development as a writer. Cézanne, therefore, was to be studied by anyone who seriously wanted to write. So it made perfect sense that when, in 1923, a shy young fan bearing a letter of introduction from Stein's writer pal Sherwood Anderson showed up on her doorstep and asked her how to write, Stein told the kid to go look at Cézanne. The dutiful acolyte did, and that's how Ernest Hemingway learned to write: "I was learning something from the painting of Cézanne that made writing simple true sentences far from enough to make the

stories have the dimensions that I was trying to put in them. I was learning very much from him."[8]

Though Hemingway later famously betrayed Stein, as he also did Sherwood Anderson, he always acknowledged his debt to her: "She. . . discovered many truths about rhythms and the use of words in repetition that were valid and valuable."[9]

So, even if you have no use for the avant-garde writing that followed Stein, you can't deny that she also gave rise, through Hemingway, to the mainstream of American realism that followed her former protégé.

While Stein always acknowledged her debt to Cézanne, she also continued to study and work with other visual artists. In the fall of 1905 she met Picasso, and the two of them became fast friends. Picasso began a portrait of Stein that required eighty sittings. During this time, as Stein later described it,

> I began to play with words then. I was a little obsessed by words of equal value. Picasso was painting my portrait at the time, and he and I used to talk this thing over endlessly. At this time he had just begun on cubism. . . .
>
> I had these two things that were working back to the compositional idea, the idea of portraiture and the idea of the recreating of the word. I took individual words and thought about them until I got their weight and volume complete and put them next to another word and at this time I found that there is no such thing as putting them together without sense.[10]

Weight and *volume* are words we usually think of more in relation to looking at visual art than to thinking about words, but Stein took these words and ideas very seriously. After sitting for Picasso, and discussing how a viewer can see the same thing from many angles, she embarked on her own series of portraits — in words — of her painter friends, including Picasso and Matisse, and wrote *Tender Buttons*, a series of cubist-influenced still-life portraits of things. Here are two of them:

CHICKEN
Pheasant and chicken, chicken is a peculiar bird.
CHICKEN
Alas a dirty word, alas a dirty third alas a dirty third, alas a dirty bird.[11]

As seriously as she took her art, Stein never took herself too seriously. Sometimes she liked silly rhymes; she often liked to laugh.

◆ ◆ ◆

As much as she wrote in the creative light and shadow cast by the paintings and painters around her, I don't know that Stein ever called her work *ekphrastic*. But, then again, Stein was also famously down-to-earth, dismissive of academic pomposity and aggressively American in her diction. In "Pictures," one of the lectures she delivered in her famous lecture tour of America in 1934, Stein recounts an anecdote about when she was asked, in a questionnaire sent her by *The Little Review*, "What Do You Feel About Modern Art?" Stein, by then revered as having purchased some of the most important art produced in the early twentieth century, answered, and I quote in full: "I like to look at it."[12]

Ekphrasis, from the Greek *ek* for "out" and *phrasis* for "speak," is the word Plato used to describe what happens when a writer writes creatively — as opposed to in the voice of a critic — about art. The philosopher who famously exiled poets from his ideal Republic didn't like that some artists, then as now, would rather, instead of making art designed to mold us into well-behaved citizen-pods, make "difficult" art, art that makes us question things, or see in different ways. Long before the mind-numbing expectation that an "ideal Republic" can only support "art" designed to end racism, sexism, ageism, able-ism, homophobia, and/or religious intolerance (anything I'm leaving out?), writers were making art because they wanted to explore something. And sometimes what artists want to explore is something created by

other artists. Making art about something created by another human being is a way to engage intimately with how another human being believes or sees or feels or thinks or wants. It can also be really fun.

Historically, ekphrasis has included art made in direct response to another piece of art, such as a painting of a scene in a play. Think of John Everett Millais's vision of *Hamlet*'s Ophelia or our own Jacob Lawrence's series after James Weldon Johnson's *God's Trombones*. Ekphrasis can also refer to art that attempts to describe how another piece of art, or an artist, came into being: Auden's poem "Musée des Beaux Arts," a reading of Brueghel's *Icarus*; novels like Irving Stone's blockbuster *The Agony and the Ecstasy*, inspired by the life and work of Michelangelo (minus the gay stuff); Michael Ondaatje's *Coming through Slaughter*, a riff on the life of original jazzman Buddy Bolden; or *Whale Music*, Paul Quarrington's fantasy about Brian Wilson and the composition of the *Smile* album. Ekphrasis can also describe an imagined work of art. Kathryn Davis did this in her brilliant *The Girl Who Trod on a Loaf*, which describes the oeuvre of Helle Ten Brix, an invented opera composer. When I read this book I wanted to go out and buy all of Brix's music, but it only exists in the minds of the writer and her readers. The most famous example of this kind of ekphrasis may be Keats's "Ode on a Grecian Urn," in which the poet imagines a kind of composite ur-urn to be the — forgive me — *vessel* for a lot for things he wants to say about mortality, eternity, and art.

Several years ago, my ekphrastic writing expanded as I began to collaborate more formally with dancers, composers, actors, and other writers. In 2004 I approached Seattle-based painter Nancy Kiefer about doing a project together. We ended up making *Woman in Ill-Fitting Wig*, a book of her images and my texts, and having an exhibition at the Richard Hugo House. Many of my writer friends loved the project and so, when Nancy had a new body of work a couple of years later, she and I invited several writers to compose poems or stories in response to it for a special edition of *Tarpaulin Sky* magazine.

In 2004 Midge Bowman was appointed as executive director at the Frye Art Museum, and the museum began making some exciting changes. When I saw that Mary Jane Knecht, whose fine work at Copper Canyon Press I had long admired, was the new manager of adult programs and publications, I approached her about collaborating. Mary Jane showed me some material for an upcoming exhibition in which film critic Robert Horton, for his lecture series at the Frye, made a connection between the drawings of Robyn O'Neil and the dark tales of Nathaniel Hawthorne. As a longtime Hawthorne aficionado, I had a hunch this work would appeal to me. In response to Robyn O'Neil's 2006 exhibition at the Frye, I wrote a tale, "The Brothers," and read it in the gallery. The event received an enthusiastic response, so about a year later, after many rigorous planning sessions at the Hopvine Pub, Mary Jane and I got the go-ahead from the Frye and University of Washington Press for the book you are now holding in your hands.

Mary Jane and I asked writers to respond to work either in the Frye's collection or that had recently visited the Frye. We weren't looking for art criticism or theory; we wanted poetry, stories, invention. Together we came up with a list and talked about which writer to pair with which visual artist.

Our collection begins with Jonathan Raban's arch monologue in the voice of a supremely self-important nineteenth-century "Professional-with-a-capital-P" painter of landscapes and ends with Ryan Boudinot's ironic then sweet story about contemporary young museumgoers looking at art and finding themselves. Between Raban's take on artist as moneymaker and Boudinot's take on art as humanizer, our writers created poems, tales, narratives, episodes, word games, and poetic sequences to explore painting, drawing, and sculpture.

Some of our writer-artist pairings were suggested by subject matter. For example, we assigned landscapes to Melinda Mueller, whose book *What the Ice Gets* is a poetic sequence about the terrain traversed by Ernest Shackleton's expedition to the South Pole,

and to Jack Nisbet, who has long chronicled the work of the nineteenth-century scientist-explorer David Thompson. On the other hand, some of the visual work demanded the writer respond less to content and more to form. Peter Pereira's collection *What's Written on the Body* contained a number of poems adhering to strict formal constraints we thought were analogous to the formal constraints Willie Cole used in constructing art from women's shoes, ironing boards, and irons. Both Pereira's and Cole's work comments in subtle ways on race and gender, on what's considered "women's work" or "civilized" or "savage." Both visual artist Dario Robleto and poet Christine Deaval find pathos in humble and unexpected sources such as science textbooks, cast-off dresses, documents from the Government Printing Office, legal contracts, and soil.

In addition to asking our writers to write for the page, we also wanted to create a live experience, and so we held a reading series in the galleries. At our first reading, Stacey Levine, whose surreal, funny books look at the underbelly of banal-seeming America, presented a creepy tale about mutant animals. Listeners in attendance that night could look over their shoulders and see Patricia Piccinini's weirdly glistening sculptures that inspired the story. Frances McCue also read that night. Her long poem was inspired by Franz von Stuck's *Sin* (*Die Sünde*; c. 1908) and the Mylar altar Victoria Haven created to surround it a century later. McCue's poem is a study in character, society, and sexual prejudice, all informed by a kind of cheap horror-movie subtext of why we ought to be afraid of mobs. As Frances read aloud, I could practically see the villagers' torches bobbing and hear the shaking of their shovels, pitchforks, and torches in the background.

Our final — or perhaps first — contributor was brought to us by Roxanne Hadfield, the Frye's administration coordinator. Roxanne pointed out to Mary Jane that Richard Hugo, a patron saint of Northwest

poetry, had published a poem called "One by Twachtman at the Frye" in his 1965 collection, *Death of the Kapowsin Tavern*.

So, while we can certainly regard this project as a way of writing in the ancient ekphrastic tradition, we can also say it's a way of carrying on a Northwest literary legacy.

Or it could be that a lot of us, like Gertrude Stein, just like to look at art, and when it really gets to us, we write.

REBECCA BROWN

NOTES

1 Gertrude Stein, *Writings 1903–1932* (New York: Library of America, 1998), 3.

2 Ibid., 223.

3 *Four Americans in Paris: The Collections of Gertrude Stein and Her Family*, exhibition catalogue (New York: Museum of Modern Art, 1970), 4.

4 *Selected Writings of Gertrude Stein*, ed. Carl Van Vechten (New York: Random House, 1946), 29.

5 Gertrude Stein, "Transatlantic Interview, 1946," in *A Primer for the Gradual Understanding of Gertrude Stein*, ed. Robert Bartlett Haas (Los Angeles: Black Sparrow Press, 1971), 9.

6 Library of America press release, 1998.

7 Gertrude Stein, *Paris France* (London: Brilliance Books, 1983), 12.

8 Ernest Hemingway, *A Moveable Feast* (New York: Charles Scribner's Sons, 1964), 13.

9 Ibid., 17.

10 *Primer for the Gradual Understanding*, 18-19.

11 *Selected Writings of Gertrude Stein*, 436.

12 Gertrude Stein, *Lectures in America* (London: Virago Press, 1988), 59.

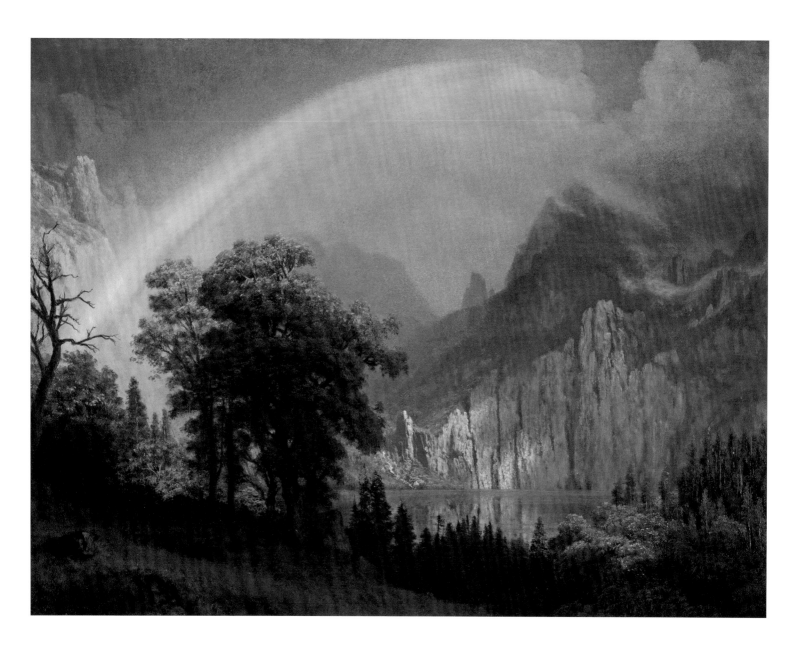

ALBERT BIERSTADT

Rainbow in the Sierra Nevada, c. 1871–73. Oil on panel. 18 x 24 inches.
Frye Art Museum purchase, 1997. Photograph by Susan Dirk.

Critics? Don't talk to me of critics! You think some jackanapes journalist, his soul eaten away by the maggots of jealousy and failure, has anything worthwhile to say of Art? I don't. When I want an opinion, I'll get it from my peers — from men of vision, like our great railroad builders. . . Stanford, Huntington, Dinsmore. . . fellows with imaginations broad enough to span the continent. They all have my pictures on their walls. Or the crowned heads of Europe. Victoria, the queen of England. . . "Mr. Bierstadt, we think it most sublime" — her very words. Twenty-five thousand dollars is what I charge for a six-by-tenner; a bargain at the price, if majesty and grandeur are what you're in the market for. Church, Durand, Moran — you've seen their efforts? Oh, they *try*. But when it comes to sublimity none of 'em can hold a candle to my work. Look at poor Church's Andes: his canvas is big enough, but where's the nobility and splendor of those mountains? He could've saved himself the expense of going to South America and set up his easel in the Catskills. When I go West, I bring back loveliness, enchantment, rapture: I loft men's souls, and paint them a world worthy of their dreams.

Not "true to life?" When I attend the opera — *Das Rheingold*, say — I want to see the spectacle, the magnificent illusion of it, not a perspiring crew of stagehands and their vulgar machinery. Same thing with the West. What would you have me do — paint in the logging camps, the miners swarming from their hovels to hack at the rock with pickaxes and drills, the filthy Chinese railroad gangs? I'll leave that kind of sordor to the Paris realists, if you please. I don't look to the gutter for my inspiration; I gaze up — to the giant sequoias, the irised spray of the cataract as it tumbles from the brow of the cliff, the dazzling wonderland of colossal snow-encrusted peaks.

I am not a camera. When I painted your Mount Rainier (a noble sight, if too plump around the middle for perfection), I chose my spot with care — a pleasant beach on the southern tip of Vashon Island, which gave me the rippled water, catching the incandescent alpenglow of the mountain in the first light of dawn, and the line of woods between. There was my picture. The ugly city of Tacoma, all sawmills and saloons, I wiped from the view, likewise the press of shipping in the bay. For human interest, I set a canoe of Indians where a steamer, dripping rust, had lain at anchor. I find the noble red man, with horse, canoe, or teepee, gives an authentic touch of the primeval to any western scene. It's *essences* I paint, you see: Tacoma was inessential, a blot on the pristine landscape of my vision. So I tore down every last brick and beam of the place — it was an eyesore — to show Nature's own drama in all its purity. A true artist must have the courage to be bold, and see beyond the *is* to the *should be*.

Look at my wildlife. Tourists from the East are still a little frightened of the West — the Donner party, they think; savages, with tomahawks and guns, plundering emigrant trains; wolves, cougars, rattlesnakes, and grizzly bears. My Indians are peaceful folk, and you'd want to pet my bears. For scale, I generally prefer the gentle deer: a doe and her fawns lapping at the edge of a windless pool will please the ladies and the hunters too. For Nimrod, I'll put in a flight of duck, for Piscator, a speckled trout — five pounds if he's an ounce — lying just beneath the water's surface, waiting to smash the angler's fly.

Here's the trick of it. Your backdrop's all magnificence: the sheer face of the precipice, the thundering waterfall, the pathless forest, the dazzling mountain glaciers. But in the foreground, I've painted you a little beach, or level glade — your foothold in the picture, where you might spread a cloth for a picnic, with potted meats and parasols, bottles of cool Sauternes, all furnished by the hotel, which is a mile or less behind from where you're sitting, and a convenient carriage ride from the railroad station along a brand-new graveled road.

When I first went West in '59 with Colonel Lander's survey expedition, we had to rough it — hard trails, hard rations, wild men and beasts, an adventure only for the fit and young. Now that the frailest invalid can board a Pullman Palace Car in New York on Sunday and be in Frisco in good time for luncheon the next Saturday, the West's within the reach of everyone — and you'd be astonished by how many men and women of culture and refinement now take the train simply in order to live inside my painted world for a five- or six-week spell. Stanford himself once told me that he owed me dinner because I'd brought a million dollars' worth of business to his road.

An hour out of Reno, when the triple-hitched locomotives begin to labor up the grade to Donner Summit, the line twisting and turning with the contours all the way, the Pullman passengers drop their newspapers and their sewing — I've seen 'em — and have eyes for nothing except the ever-changing exhibition in the window: that lake! that fall! that massive crag! that herd of deer perched on a green outcrop two thousand feet above the valley! And every picture's one of mine. It's not California they're seeing, it's Bierstadt: my trademark Æ signature's on every view.

Now take the great unwashed in the second-class and emigrant cars — I've seen *them* too. We're on the same stretch of line — Verdi to Auburn. What do you think they see? Donkeys and hydraulic sluices in that placer mine — might get a good job there. Fallers and riggers bringing down a tree. . . a row of shanties. . . the gaudy false front of a general store. Such things catch their interest, but to the grand vista they're entirely blind.

I've taught the better class of tourist both to see and not to see; to lift their eyes above and beyond the inessentials, and thrill to our western Nature in her majesty. And not just tourists, either: every hack photographer tries to copy what I do. He sets his tripod where he imagines I'd put my easel, swivels his camera this

way and that, searching for the "Bierstadt composition." It's a fool's game: all the fellow gets are molehill-mountains, waterfalls that look like so much washing on a line, and everything caught in the arid glare of the midday sun. I often use a camera as a handy *aide-mémoire*, but it can no more see the true landscape than can the malodorous fraternity of the emigrant car.

That little oil you have there, with the rainbow. There's Bruin, a black smudge down to the left, a timid creature, shuffling through the grass, sniffing out a bees' nest for its honey, I wouldn't wonder; and on the other side, between the trees, a little garden of bright spots of color, foliage and flowers, just as you might find them clustered around the door of an English cottage, or in Eden.

As for the rainbow: to the Bible reader, it's the symbol of God's covenant with His creation, as He told Noah in the book of Genesis. I'm no churchgoer — too busy painting to nod through sermons on a Sunday — but I like that hint of Nature directly touched by the Divine. You see the freehand sweep of the brush, lightly laden with color, kissing the canvas. . . the crimson, the yellow, and the blue. That was the finishing touch, done in a few seconds in the studio, and it makes the picture — God smiles on California!

But the real heart of the piece is in the lighting. There's a problem with the Californian light, *au naturel*: too harsh, too dry, too clear. Distances collapse in it — a mountain fifty miles away looks five. In the West, Art has to compensate for an unfortunate deficiency in Nature.

You've seen Wagner's operas, in Munich or at his new house in Bayreuth? The man's a master of lighting, as he is of music — no one knows better how to work the magic of gauze and gaslight, and the electrical arc. I've learned a thing or two from Wagner, and it shows here. See how the limelight is directed on those rifted cliffs — Nature's architecture, taller, grander, than any European cathedral you can name. And see how a crossbeam, filtered rose-red, makes the great precipice to the left glow with color snatched from the rainbow's topmost edge and turns the foreground tree into almost-silhouette? The first shaft picks out that majestic sculpted buttress and the tumbling crystal stream beside it, then softly shines upon the tranquil mirror of the lake; the second — my rainbow effulgence — serves to emphasize by contrast the evening mistiness beyond, the ambiguous intermingling of cloud and soaring peaks.

You're in a darkened auditorium. The last notes of the overture come to a close, the curtains part, and you're rapt in the play of astounding light upon the scenery. You don't "look at" this painting, you commune with it; and, by so communing, you commune with Nature herself, the Sierras, the Great West — and all by the transforming power of Art in the hands of a master impresario.

It's eighteen by twenty-four inches, at a glance. My usual price — but I'll break my rule, and let you have it for a bagatelle. Exquisite sublimity in just three square feet. Twelve hundred dollars. What do you say?

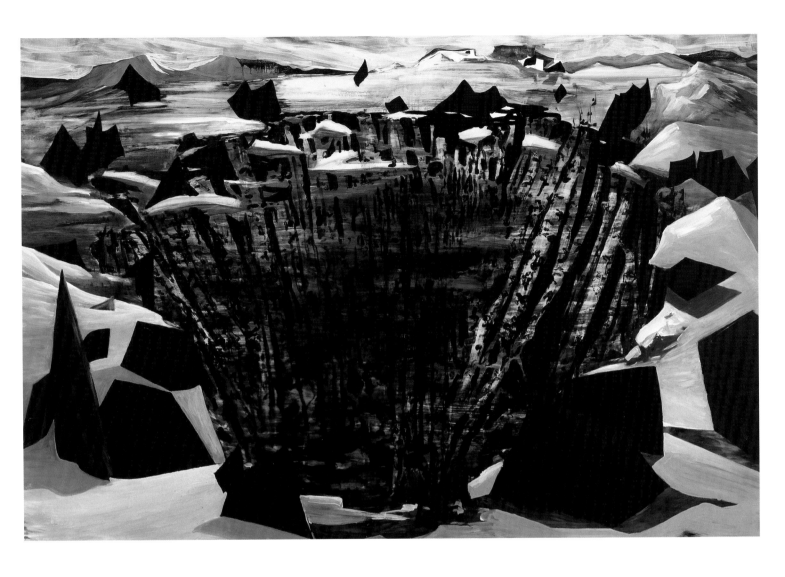

SIGRID SANDSTRÖM

Ginnungagap, 2004. Acrylic on polycarbonate. 48 x 72 inches.
Courtesy of the artist and Inman Gallery, Houston.

REDBILLED
QUELEAS:
ONGAVA, NAMIBIA

MELINDA MUELLER

 Towards dusk they come
flocking out of the veld
 to roost
 in thorn trees smoke
 with wings ashes with
 wings
 what
 is Judgment Day but
 the Dead
 in their scattered
parts
 rising thus
 a torrent a surf-beat
 roiled molecules the air riven
 and pungent
 as from lightning
 flagrant scarves
 or a Colossus
 conjured of weightlessness
 what is
 a symphony
 but beaked notes
pouring from staves they pause
 into the thickets
 spool aloft
 settle
 feather branches
 with clamoring foliage
 a fountain's droplets
 splurging up and out a galaxy
 both particle
and wave what is a species but this
 statistical cloud tendered
 to time and chance?

 Darkness folds them
 into the trees.

 Thousands of
 silences
 fall.

*Gouache on paper creates a soft,
smoky opacity.*

Epigraphs: Robin Held, "Exploring
Bodies, Explored Spaces," in *Gin-
nungagap: Recent Work by Sigrid
Sandström* (Seattle: Frye Art
Museum, 2006).

To our rooftop breakfast table, the back of an angel presents itself from the church adjacent. The iron braces that secure its wings remind us that the angels here are pinned

or they would fall. Yet even so they seem to fly. In Sant'Andrea al Quirinale, they curl like gilded smoke to the cupola that lets in heaven's light; in a side chapel

of San Sabina, the Madonna is borne from this heavy earth by a confectionary of angels in pastel. *How easily the blown banners change to wings*, how easily

candle flames beat upon the air and lift the burden of their prayers. *L'aria*, the melodic wind; the brilliant-plumaged clouds above the domes at sunset —

how easily even travertine takes flight, even the bone-scented plaster of Borromini's Sant'Ivo carries the eyes upward, to the windows where its fontanel will never close.

About our feet, sparrows peck at crumbs; swifts maneuver overhead and gather insects for their daily bread; pigeons drag greasy *salviette* out of gutters. These

are Rome's *messaggeri*, who bear the news of all of which we're careless, all we disdain to notice, all we discard, and by which we shall at last be judged. They are smithied by a lame god.

THE BIRDS OF ROME

One must move bodily to experience each work in its turn. . . In this way the artist insinuates the viewer into the landscape.

They creak among leaves; they rasp files
In their metal throats; they smell, like blood,
Of iron. Just when we're beguiled

By the roof over our heads — matte blue
Or fleeced with clouds — they hew
Our sky like hatchets with their flight
And put it all to tatters, pierced with night.

In genial parks, they strut about the lawn,
Shadows casting shadows. Light dies
In them as it does into a grave. They gleam eyes
Of carbon at the living. . . But this is a human

Conceit. They are tenebrous like us, and truculent.
The rest is all reflection. They are innocent.

CROWS ON A
SUMMER DAY

*Acrylic on Mylar or
polycarbonate gives a hard,
impenetrable effect. . . The
reflection of the viewer's eye
might all but overwhelm
an ice floe.*

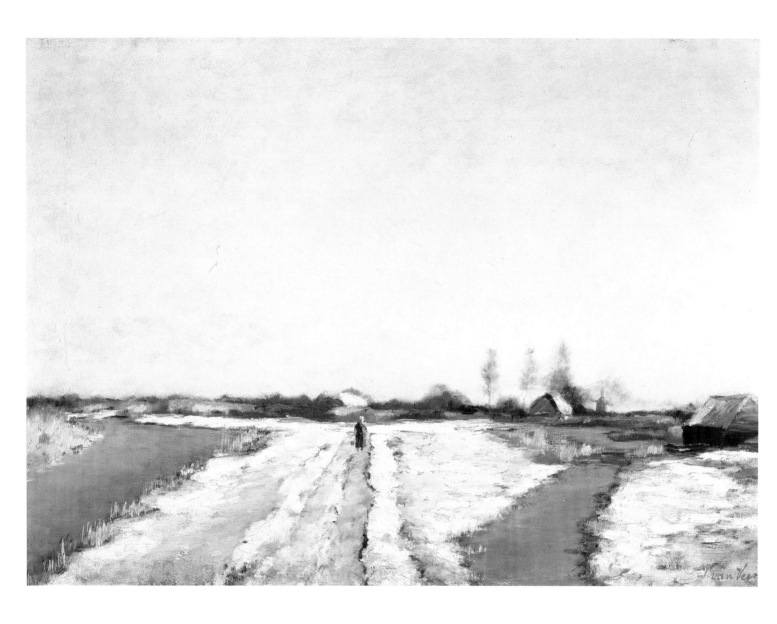

PIETER VAN VEEN

First Snow, 1914. Oil on canvas. 15 x 21³⁄₁₆ inches.
Charles and Emma Frye Collection.

We parked the car in the field and cut the dogs loose; they frolicked through the skiff of new snow, writhing like snakes and tasting the white crystals in their mouths. Though the dawn was past gray, the sun had not yet appeared, and cold air cloaked the basin around us. We stomped across the frozen road knowing it was close to zero degrees, with no day above freezing all week. Surely that would be enough.

Tiny trickles of water sounded where the stream emerged from a steel culvert below the roadway, then formed into ice that was bumpy but plenty hard. We scuffed our shoes downstream a few yards and swept away the light snow to reveal ice that had been shaped by the wind into intestinal ropes, rough but skateable. We searched for flat rocks so we could plop down to wrestle on our blades, then stood up into the season's first slow, tenuous glides.

The stretch of channelized creek bordered by thickets of reed canary grass ran so straight that it was hard not to think of Holland and Hans Brinker and the magic of a child making smooth, noiseless speed along ice highways for hours on end. As we gained our balance, all four skates began to cut longer arcs into the snow, line upon line. Hans's nineteenth-century dream died within a few hundred yards, however, because a recent conservation easement had determined that the canal should revert back to its wetland state. Beyond a simple crossways ditch, the canal exploded into a reborn marshland. The weedy thicket gave way to mounds of native bunchgrass frosted with white, and each hummock was defined by skeins of light cattails and dark rushes. Within their tangle of stalks, the first cold rays of sun glinted off the beginnings of a maze of puddles, ponds, and small lakes that wove across the basin like the runes of some ancient script.

My attempt to stretch one long skated step into the first of these separate ponds snagged on a clump of sedge that sent me sprawling. As my body plowed a path through the white blanket, I could feel this new ice was much smoother. Stopping with my face inches from the surface, my gloved hand sensed a pattern of tiny dimples that might have been pores in skin. Then just beyond my reach, dotted into the fresh snow, a line of clear weasel tracks bounced across the pond to disappear among the mounds. Those tracks called up the Netherlands again, like a detail from Rien Poortvliet's visions of his home country. Poortvliet is a modern Dutch artist who caresses his landscape in real and imagined time. His book *Journey to the Ice Age* pauses for a look at the Low Country of two centuries past. There a sly poacher one-hands his ferret from a wooden box, intent on bringing down a royal rabbit for supper. A line of illegal duck snares drape

across a waterway, catching legs. The great wolf scare of 1811 spreads terror through a village as goat-herding children watch a big lone male drag off their smallest sibling. The herders tear back from the fields to a farm not unlike the group of buildings situated on a gentle wooded slope above our present reclaimed wetland in eastern Washington: root cellar, chicken coop, skeletal barn, windowless brick house, all long abandoned; a homestead that worked for a while and then did not. From across the wide Atlantic, their kid calls bring the mother flying out of her kitchen, flinging strong arms open to scream with the old-time righteous terror that signals children at risk.

I thought of the danger now, sitting in my own skid mark and running my fingers across the icy skin. None of these ponds could be more than knee-deep. I had another kid with me this morning, but by now he had skated ahead, smoothly drawing long arcs toward the sunlight. Lumbering to my feet, I leaned around the kidney shape of this new rink, took three tiptoe steps across frozen bunchgrass to reach the next larger pond, and swung away, chasing my son and the leaping dogs to the next untamed body of water.

Powder snow dampened the hiss of my blades as Rose Butte rose into view beyond the abandoned homestead. I could smell the stiff sagebrush up there, bristling through the snowcap, and trace the fluted basalt arranged like battlements along the top edge. The butte wasn't a very large feature, but it proved that we were not touring some straight canal in the Holland's calm coastal plain. The escarpment here had been violently scoured down to bare rock by a series of ice age floods, which along their high-water mark had left behind evidence of a risk-filled world. We were out West, in the dry country between the Rocky Mountains and the Cascades, where some fever dreams still feel alive.

In 1876, only a few miles east from this marshland, five brothers had excavated a whole herd of mammoth bones from a similar bog below their farmhouse. Word spread quickly among the neighboring homesteads, and, busy though they must have been, that summer Palouse farmers conjured the remains of turtles, birds, horses, bison, and musk ox up from muddy depths behind their homes. The Pleistocene emerged from those backyards, and despite the millennia since the demise of the big animals, the buzz of excitement around the bones hinted that some unbreakable thread still connected then and now.

At the end of that centennial summer, a group of homestead neighbors south of Spokane rigged a gin pole to raise an eight-hundred-pound mammoth skull from the bottom of a spring. In time, paleontologists at New York's Museum of Natural History used that massive skull to codify our totem ice-time species: the Columbia mammoth. Such elephants would have crashed through aspen groves and touched their trunks to the pungent bitterbrush and sages that still claim these scablands. Their tusks grew in lyrical curves that scraped the bunchgrass; their bodies sprouted single long hairs rather than an entire shaggy coat. Warmed

from within, the mammoths of the Columbia country traced the advances and retreats of glacial lobes for a million years. During the course of the final meltings, failed ice plugs on a lake to the north unleashed a series of mighty deluges across the landscape of the Columbia Plateau. It was around this time that the fate of the great beasts began to intersect with the righteous desperation of human beings.

2

As successive walls of glacial meltwater moved downstream past Rose Butte, the swirling floods carved a web of scabland coulees and shoestring lakes. One of our favorites has a boat launch at its outlet that lies near an ancient campsite. Some years ago the parking lot yielded a Clovis blade perfect for carving meat off a mammoth carcass, and it's hard to walk around there without looking at the ground. But on this particular day, it was the frozen water that captured our attention: the ice below the ramp seemed to flow with the purity of India ink.

We edged onto the pane of glass and bent close to gauge its thickness, surprised when white bubbles locked inside the blackness seemed to descend four inches and more. Then a deep crack thrummed beneath the sheet, sending a single shiver across the soles of our feet. The shoestring lake winds in a crescent shape beneath hundred-foot cliffs of columnar basalt, and the sound resonated off the walls as it ran the entire length of the lake and back again. When a rock wren scolded us from the talus slope below the sheer wall, each raspy call rode atop the echoing wave. As both died away, a steady low music seeped into our awareness from around the corner: water working rocks.

It was a mile and a half of clear sailing to the lake's north end, and over the black ice we covered the distance with breathtaking speed. Where the cliff face crumbled into unruly scree and knobs of pillow basalt, we eased off and circled back, trying to hold the edge of safe ice. Right there, a mostly frozen waterfall descended off the plateau through a series of stairsteps and plungepools before disappearing into a ragged flat of shattered stones at the lake's edge.

Midway up the staircase, modern hunters had stacked enough rocks beside one crag to form a serviceable blind. Past hunters could have laid up similar blinds, when the bones in the plungepools belonged to animals other than cows and mule deer. We imagined something large thrashing in the shallow water, one of its legs shattered on the slippery stones. The men, women, and children who crowd around it hesitate before going in for the kill. Danger, they think. Like Poortvliet's farm woman, they sense a risk of genuine magnitude. We feel the same thing, and its power draws us closer to the aerated open water below the falls. How close do we dare approach?

We are flying now, following the ebb and flow of animals and seasons and geologic time upstream. We have been cut loose in the dry country of the American West, between the big mountain ranges, and as we move north they pinch together into the Rocky Mountain Trench, a seam that hinges the North American continent. There the source lakes of the whole Columbia River touch the beginning of the story.

In February they are lakes of white ice, vast sponges wedged between the peaks of the Rockies and the Purcell Range. At thirty below zero, in the dead silence of a still winter day, the ice sings like a pod of humpback whales. Doppler effects dance around every tentative step as we try to figure out how we can possibly skate on a surface that rides with the hummocks and dips of topographical relief.

At Columbia Lake's south end, we push off from a curling rink that has been lovingly swept clean and marked for play, one speck of organization imposed on eight miles of random ice. It is slow going out in this wilderness, because the surface is marred by pressure ridges that make for sudden drops. Open cracks have struck like lightning and refrozen as black lines on a white field. There are cornified soft spots and bubble seeps that can catch a blade and send you flying. But a few hundred yards away from shore we find there are also vast stretches of milky, refrozen, rock-hard snow on ice.

Although it feels curved rather than flat, this surface skates just fine, allowing us to work north for mile after mile. I remember listening to Alfred Joseph, a Kootenai who for years ran pack-horse outfits into the mountains above here, describe trails across to Alberta that had been worn smooth by people treading over and back, over and back, for thousands of years. In places, Alfred said, grooves a foot deep had been walked down into the rocks.

North West Company fur men built their first trade house at the source of the Columbia only two centuries ago, among Kootenai people who provided them with the food and information that kept them alive. The newcomers struggled through summer and fall, but as the weather turned cold, groups of elk gathered on winter range above the post, and trumpeter swans floated in warm sulfur pools around the lake's north end. Fueled by bird fat and lean venison, the traders gathered with their hosts during winter evenings and listened to stories of the land. When agent David Thompson heard one about large scary creatures in the mountains above them, kneeless monsters who had to lean against trees to sleep, he filed them away as "nursery tales." He did not mention that a medieval bestiary written in England described African elephants as the same sort of jointless leaning dozers.

During a winter crossing of Athabasca Pass three years later, Thompson's crew struck a line of large tracks in the snow that set his Cree and Iroquois hunters on

edge. The sign was distinct, fresh, and carried on for several hundred yards. Thompson noted that each track showed four three- or four-inch toes, with a small nail at the end of each. He carefully measured a few of the clearest prints at fourteen inches long by eight wide.

The Kootenai had told his hunters of a "large unknown animal" that plied those slopes. The men even pointed in the direction of a mountain where the creature was supposed to live. *On the top of the eminence, there was a Lake of several miles around which was deep moss, with much coarse grass in places, and rushes; that these animals fed there, they were sure from the great quantity of moss torn up, with grass and rushes; the hunters all agreed this animal was not carnivorous, but fed on moss, and vegetables.* None of the guides had actually seen the vegetarian monsters, but all assured their boss that they had no interest in tracking this one down.

Ross Cox, an Irish fur clerk and occasional teller of tall tales, crossed the same pass five years later and heard the same stories from the company's mixed-blood hunters. According to Cox, these hunters alleged that the animals stretched two to three hundred feet in length and were tall in proportion. The men said that the beasts formerly lived in the Great Plains and far to the east, but that the Indians there had gradually driven them into remote mountain valleys. One hunter, in fact, swore that his grandfather had seen the animal long ago while crossing just such a mountain pass. *On hearing its roar, which he compared to loud thunder, the sight almost left his eyes, and his heart became as small as an infant's.* Cox, who like many people of his time had heard about large bones being dug up out of the ground, later speculated that his hunters might have been talking about a mammoth, and it's easy to catch the whiff here of a true encounter, passed down and amplified by dozens of grandfathers around many winter campfires during story time.

In his own later years, David Thompson revisited his Athabasca Pass encounter with the large tracks. On the one hand, he compared those same hunters' natural-history ruminations with contemporary accounts of large ivory tusks thawing out of ice in Siberia. On the other, he decided that despite the trustworthiness of his experienced hunters, their 1811 party ascending Athabasca Pass must have cut the tracks of a large grizzly bear. But Thompson couldn't bring himself to deny the possibility that there might be a mammoth out there somewhere, stepping new prints into fresh snow, and he always remained in awe of what secrets the vast reaches of the Mountain West might hide.

Ice and cold are elements that greatly expand those reaches, opening up ever more possibilities. They override the heartbreak of living on tough land for generations, of going broke, of lean hunting years when no animal approaches the blind, of communities erased by disease and devastation. A good winter howls

across the landscape like a message that can be read but not quite understood: Who are the people? Where does the fear come from? What is that uneasy sense of change that hangs in the air?

Today marks the beginning of another time-collapsing winter, and we can only hope that the air stays cold. I bend my knees and swing my arms hard, looking for the story that made that woman so desperate, listening for a sound that might shrink my heart. There must be a smooth path out here somewhere that will get me through this terrain and let me skate deep into the mountain's cold embrace.

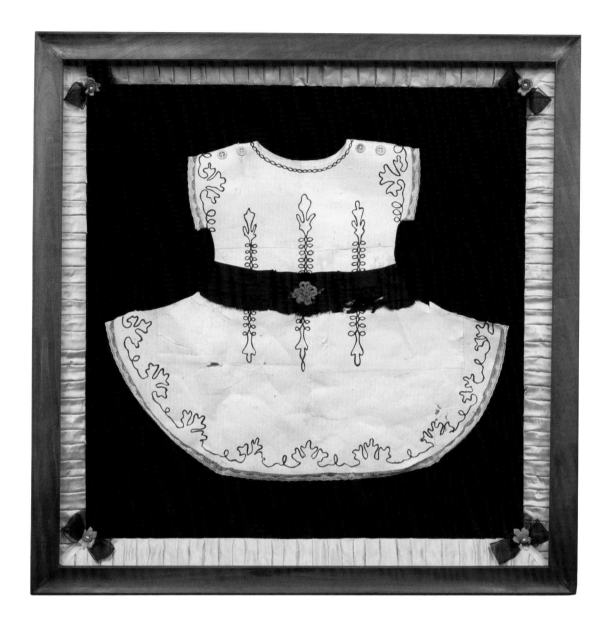

DARIO ROBLETO

A Century of November, 2005. Child's mourning dress made with homemade paper
(pulp made from sweetheart letters written by soldiers who did not return from various
wars, ink retrieved from letters, sepia, bone dust from every bone in the body), carved
bone buttons, hair flowers braided by a Civil War widow, mourning dress fabric and
lace, silk, velvet, ribbon, World War II surgical suture thread, mahogany, glass. 38 x 38
inches. Collection of Stanley and Nancy Singer, East Hampton, New York.

Of the bird's wing, there are tracts of feathers, each with its own name. The crown, the breast, the mantle. But also there are the coverts, those layers of feathers beneath, that cover the base of the feathers below. Covert means shelter, a place for the hidden. Before white settlement, Indiana was covered by more than two billion trees. Barely two centuries ago, it was nearly completely a canopy of forest. And threading the forest were millions of acres of marshes and swamps, almost a fourth of the state. By the Eel River, not far from the Wabash River, I grew up in a town surrounded by vast, flat tracts of farmland. I know there was a land of forest and marsh, and I know that it is gone. The knowledge may be a kind of covert, the absence become presence again, the gone become hidden. Knowledge not as comfort but as shelter.

OF THE BIRD'S WING, THERE ARE TRACTS OF FEATHERS

CHRISTINE DEAVEL

PRIMARY COVERTS

Short-Eared Owl

A young man who was crossing
 a partially inundated field
 counted these birds as they arose
 before him,
and at one time there were thirty in the air.
 There was only one tree
 and they all alighted
 on that tree.

Least Bittern

The nest,
a few inches to a foot above
 the water,
placed upon a few stems
 or leaves of the cat-tail,
which the bird
had evidently bent down
 and arranged
into a shallow, insecure nest.
Did not see the bird
on the nest in a single case,

so watchful and shy
are they.

King Rail

One nest, twelve eggs,
found by Mr. Steinman,
built in over-flowed meadow;
consisting of broken, dried cane;
the nest proper very small
and the eggs piled up
on top of each other.

Henslow's Sparrow

Hearing a rustle in the grass,
looked down and saw a bird
 which ran like a mouse.
It stuck its head under some
 leaves and grass,
 leaving its tail exposed.
Had to back some distance to shoot it.
 The males were in full song.

Black-Crowned Night Heron

Large numbers in the heronry,
and many flying over
carrying sticks
and building.

White-Crowned Night Heron

The nests among the tall ash
and sweet gum trees
 in a creek bottom.
Several fine specimens
were secured, and it was noted that
 the delicate, almost luminous,
 yellowish buff of the forehead
 very soon faded.

rare visitor rare winter visitor perhaps by mistake
now considered an error accidental mentioned by error
former resident perhaps found in the lower valley rare
this is an error occasional in winter straggler it seems doubtful
known from but few localities accidental northward
possibly may not be found at all within our limits

To move through land as a place of subsistence is different from moving through it as a place of commercial surplus. Between 1830 and 1840, Indian landholdings in Indiana decreased from nearly 4 million acres to 30,000. Eventually those, too, would be ceded or partitioned among the remaining members of the remaining tribe, the Miami of Indiana, no longer recognized by the United States government. I lived by Miami Avenue and belonged to the Tribal Trails Girl Scout Council. The town was giving itself hints. The words were retaining a place of subsistence.

GREATER COVERTS

The cessions are as follows:

A tract lying east of a line running opposite the mouth.
 Of a portion and finally of the remnant.
Small and great confluence bounded
 by crimson.
 Woods, the breadth and in tracing.
 Of that river, strips, minutely laid down.
The December end of the portage place.
 Also the overlapping voice of all lakes.

This ended all Indian tribal title
to lands within the State of Indiana.

The red-winged blackbird has a supple song, like falling water, a fitting thing since it is drawn to water. A red-winged blackbird perched on a fence at the edge of a ditch that edges a field is a sighting worth calling out in the car on a drive that is nearly all fields. The draining of great tracts of marshland in order to make of them great tracts of farmland was made possible by the ready availability of clay pipe, which lined the ditches and drained the water away. Toward the end of the nineteenth century, hundreds of factories in Ohio, Indiana, and Illinois made

earthenware tile, as it is called, to carry the water away from the land. The red of the red-winged blackbird is the startling thing in the landscape, which is field upon field upon field. It is worth saying its name out loud.

LESSER COVERTS

cracking pearlymussel (possibly extirpated) fanshell fat pocketbook northern riffleshell orange-foot pimpleback (possibly extirpated) pink mucket pearlymussel purple cat's paw pearlymussel rayed bean ring pink mussel sheepnose tubercled-blossom (possibly extirpated) white cat's paw pearlymussel white wartyback pearlymussel

MEDIAN COVERTS

How clear this space. Sore want to do,
a seed left dark or drowned.
Burred fear, sewn pelt, a cut that flew.
Risk rest — whose voice is bound?

Low wings from trees, a love pure red.
Redress is nightly turned.
What listens for us, us of thread?
Snow word, a gate in earth.

Knowledge comes as a covering snow; below is the old understanding. And knowledge from learning, that is, from words, unlike through experience, gives no memory (except of the moment the blind was raised). But to walk through it, to walk through the snow as it falls, is to walk through another's memory, even if it is only the land's. There is the cardinal, unseen until now.

UNDERWING COVERTS

Following the courses thereof,
thence to the place of beginning,
to the place of beginning,
to the place of beginning.

Primary Coverts: Lines taken from *The Birds of Indiana: With Illustrations of Many of the Species; Prepared for the Indiana Horticultural Society and Originally Published in its Transactions for 1890*, by Amos W. Butler (Wm. B. Burford, printer and binder, 1892). These birds are endangered in Indiana.

Greater Coverts: Words and phrases drawn from *Cessions of Land by Indian Tribes to the United States: Illustrated by Those in the State of Indiana*, by C. C. Royce (Washington DC: Government Printing Office, 1881).

Lesser Coverts: Drawn from *Endangered, Threatened, Proposed, and Candidate Species* (U.S. Fish and Wildlife Service, Region 3: Illinois, Indiana, Iowa, Michigan, Missouri, Minnesota, Ohio, Wisconsin, February 2007).

Median Coverts: A sonic translation of the poem "No Bird" by Theodore Roethke.

Underwing Coverts: Drawn from descriptions of land ceded by the Miami Nation of Indiana in the treaties of 1818 and 1834.

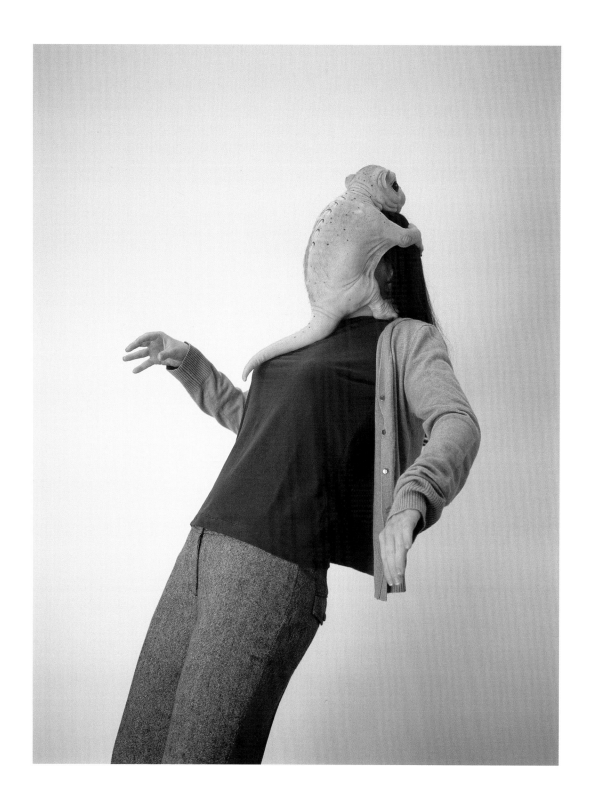

PATRICIA PICCININI

The Embrace (detail), 2005. Silicone, fiberglass, leather, plywood, clothing, and human hair. Dimensions variable. © Patricia Piccinini. Courtesy of the artist and Yvon Lambert New York.

STACEY LEVINE

Let no one take her away — she's only a little cat. Dark fur: an aggregate of rich needles, each rounded, soft, and urchin-thick. Brook loved the cat, carried it out on the balcony. Her boyfriend is a cat! The kids yelled it on the block. She had moved to the city from another city and didn't know the people. She closed her curtains. She had named the cat Sis because there were similarities, facially, between her younger sister and the cat, as she told her mother once on the phone, before the mother sputtered "You're nuts!" then hung up, crying.

The cat had been a year old and wild when Brook found it, and never became fully domesticated. When Brook grabbed Sis to brush the oily, dandery hair, the animal displayed an adrenaline-soaked fear, panting so its cheeks puffed, staring ahead, terrified, ears flattened, crying as if about to be murdered. But Brook brushed Sis assiduously. This recalled the struggles, years ago, in brushing her sister's hair. Brook couldn't help adoring Sis, and loved to watch at mealtime when the cat was at its feral weirdest, dark lips and whiskers twitching, body jumping and startling, grunting above the food and even purring, as if enjoying the food while fearing being eaten. When a kitten, Sis had lived in an abandoned city block crawling with wild life, even raccoons. So she must have found pleasure in the condition — but it really was an entire existence — of being not-devoured.

"She's only a cat, but I love her so much," Brook told a man on the telephone. But in a few days the man was gone, never calling again, which was fine, because Brook had Sis; she told the cat everything.

As the most fragile object in Brook's home, Sis could never go outside, of course. The cat's wax-yellow eyes were sometimes winsome, and expressed wishes, expectations, and dislikes, Brook thought. But most often Sis lived in a continuous push-pull between her wildness and semidomesticity: moving toward Brook then bolting away, eking toward Brook's hand then running to hide, seized by an overwhelming fear of being close to a human. Brook loved to see wild cat's difficulty in trusting. She loved to be with Sis, as lovers famously want only to be with the other. Saying *I have to go home to my cat*, she felt proud in front of the shopkeepers on the street. *I have this responsibility*, Brook thought, and liked it. She could not tolerate the thought of Sis dying; it was a ruthless idea that weakened her. Sis was already four years old. So it made sense to have the cat replicated now, before it died.

Life is shockingly short, Brook told herself, sitting on the sofa in the afternoon, holding a tiny, white phone; even men and women who are famous among other

humans are not well-remembered, decades after their passing, and so disappear. Brook held a pamphlet, around which ran a silver border, thick and continuous. Studying it, she breathed in. Brook felt that the Frinth Foundation of Life was good. Named for a spearheading scientist who had died of the flu, the Frinth Foundation was not even wholly a foundation, Brook learned shortly after phoning, speaking to a receptionist or secretary. The Foundation was actually a company, even though no one person owned it, and this was very good, the employee explained, sneezing, because companies are stronger than foundations in certain ways, with broader or deeper watering systems for financial nourishment, and companies have better armor overall, along with better ways to hide from the law, and so were less likely to die.

Squeezing the toothbrush-sized phone, dampening it, Brook asked further questions. The secretary or representative, Mary, explained that the Frinth Foundation worked methodically and fruitfully all along the border of life and death, and that while it encouraged life to ignite, nothing could really make life, the woman said, except the magic seeds themselves.

"Magic seeds?" said Brook, and snorted.

"Well, that is one analogy we use," said Mary. "The Frinth Foundation of Life is not crassly commercial. It is difficult to find the language to describe what we do," she said. "It might even be easier using words from another alphabet."

"But," Mary went on, "we want to get to know *you*, to fully screen *you*," and Brook felt warm.

After intake and instructions, it was nearly done. Brook closed the phone and stared through her large front balcony window at the change in season, which brought a rotation of her senses. She went to bed for the rest of the day and night, using not pills or encouragingly scented sleep-creams to relax herself, but instead, images in her mind of the new cat, the one to be born, an identical sister to Sis, who in turn was so much like Brook's real, troubled sister. It was a thought that brought a calm sensation: she, Sis, and the new cat, the three of them, playing, being weak together. The image pushed Brook close to a border she never had seen before, which contained almost the biggest feeling of her life.

She woke to a sharp discomfort of the morning dark, because it was difficult, in the dark, to believe light would arrive, or that there was such a thing as light, as though she or the culture around her had imagined it. The darkness seemed to make such an overwhelming statement against the light; and considering this, Brook dropped back to sleep.

In the Frinth Foundation of Life's consulting room, Brook was greeted not by Mary, but instead by a pale woman with freckles and a suit who handed her some paperwork and led Brook to an empty cubicle that may also have served as a short hallway. The place smelled as if a cellar were nearby. Brook had brought the

completed biopsy punch kit that had been sent to her in the mail, and, though the Frinth Foundation of Life did not require it, she also had brought a bank envelope filled with Sis's hair and dandruff, which she had scraped from the cat brush. Brook handed everything to the woman with freckles and a suit, who turned around and yelled "Charlie!" in a loud voice, and a longhaired girl of about twenty appeared and took the envelopes, smiling widely at Brook, then at the wall, as she loped away.

When the woman with freckles and a suit spoke, her voice came from far back in her throat, almost beneath her ears.

"It'll be the initial twenty thousand," the woman said.

"I know that already," said Brook.

"Plus half the balance in October."

"Fine."

"And October is coming up soon," the woman said.

"I know what October is," said Brook, irritated.

"So," the woman said.

"I'll pay you if we can sit down somewhere!"

The woman went to a desk. While paying, Brook said, "What if something goes wrong?"

The woman said the new pet was guaranteed. The animal would be delivered to her home at a time not yet specified, but at some point before deep winter arrived.

Brook wanted to ask something more, but she did not know what. As the company presented it, there seemed so few details, nothing to discuss. Where the white wall and the floor met, she saw a seam gaping above the baseboard, a kind of flap in the wall, as if the wall were not made of board or concrete, but wind-blown fabric. "What if the new cat," Brook said, "doesn't act like my cat, Sis?"

"There are so many ways to act," said the woman, "even for a little cat." She handed over some papers and a receipt, and Brook left the building, swarmed by cars.

2

Winter did not arrive easily, because the weather kept reverting to warm. Then the season pulled forward.

It was noon. Brook got out of the shower, her feet at their softest, pink and damp. The perpetually itchy, red patches on her legs and arms were rooted far below her outer skin, but showering helped relieve the condition. She did not think about this, though; she was excited and impatient for the new kitten to arrive, and wanted to tell someone. In her robe, Brook went to the back balcony, looking to the balcony next door.

"Hello," said Brook's neighbor, who sat there, smoking, an air of nastiness

about her. But Brook began telling how the new cat would be delivered, though she refrained from mentioning that it would be a copy — a type of sister or daughter — of her own cat. She wondered what the neighbor woman, louche in her black robe, sunglasses, and flowered tiara, would say if Brook told the full truth; perhaps she would just smile, as she was smiling now, her mind elsewhere. "So many cats have lived and died," the woman said, rising from her chair. The Olympic games were now on television, she added, and she must go to watch them; the woman went inside. There are too many people in the world, Brook said to herself.

As Brook stood by, the new kitten waddled on the carpet. The big head bobbled uncertainly. The kitten was adorable, with its baby features. It pounced, moving constantly. Hiding under an end table, Sis watched the kitten, and hissed miserably.

"Stop it, Sis." Brook said. "She's our sister. She's just like you. So be nice."

Yet the kitten was not identical to Sis, had a lighter colored coat than Sis, and was not shy in the least. These facts nagged at Brook; for the kitten seemed not the duplicate, but the opposite, of Sis, in fact. The kitten was a plump, happy creature, unafraid of people. Plus, Brook noted, its tail was strange. It was fluffy, not like Sis's slim tail, but ridiculously outsized, fuller and longer than a kitten's tail should be. The thing looked like a paddle, and collected fuzz from the carpet, which made the tail look even bigger.

"I'll call the Frinth Foundation and give them hell," Brook said, irritated in general that week, her skin itching besides. But she put off calling, and spent the week in a routine of gym workouts and shopping for a luxury cat tree. She also focused on her hobby — written and sketched accounts of her nighttime dreams, which were fantastic, like adventure stories that could happen to an astronaut.

It occurred to Brook how alone she would feel if the kitten and Sis both died or ran away, or got burned up in a fire. So she began to collect clumps of their fur and skin-flakes, storing these in an envelope.

3

It was noon. Brook woke from a nap, disoriented. She lay there for moments, thinking. The kitten was a disappointment. Brook did not like the way it would sit on the couch with its mouth open, except it was not panting, its unwieldy tail lying there like a little fox beside it. And the creature had gained so much weight that its fur had become scant and sparse around its belly.

She tried once to cuddle the thing, knowing that infants who are not touched by caretakers often wither and die. But the kitten had scratched her, and she dropped it on the floor. In the midst of all this, Brook began to ignore Sis, though

it was Sis's own fault, Brook reasoned: the older cat's wildness made her very limited as a pet, and Sis's hiding under the furniture was getting tiresome.

Brook did not want to shower to help herself wake up, because she had showered twice already. But when she finally stretched and walked into the living room, she saw a small, decorative glass apple broken on the carpet into two sharp chunks. The kitten's leg and flank had two thinly bleeding wounds; a streak of blood trailed from its nose as it slept on the floor. Sis sat nearby, in plain view on the mantel, surprisingly, giving herself a meticulous bath. Sis, too, had a long gash on her flank, and it leaked.

Brook thought she might throw up her breakfast. "What happened?" she cried. "Did you both cut yourselves on glass? No, it couldn't be that. . . did you fight?" To the animals' silence, she said, "I never know where I am with them."

She cleaned both cats' wounds with a cucumber-scented cloth, and Sis struggled, running to hide under the couch. "Sis, if you attacked your sister, it's just because you're jealous," Brook chanted softly, waiting a moment, savoring the idea that Sis might compete with the kitten for her attention. She finished wiping away the kitten's blood, then felt something hard on its belly — a lump. "You have so many problems," she told the kitten.

In the following days, the kitten's wounds did not heal well. The two gashes grew wider and more raw, bright red, even as the kitten played with bread clips and leaped almost as high as Brook's waist, making Brook laugh. The fur around the wounds had drawn back widely, too, so that, more distant from the wounds, areas of dark skin now lay exposed on the kitten's flank and rear leg, though it was difficult to tell if these hairless areas were due to the kitten's continuing weight gain, or to the skin's reaction to the wounds. In any case, the big patches of bare skin widened over time, and then spread toward the belly; they were now part of the animal's body's geography. Brook washed the areas repeatedly with water and a brown soap, in order to encourage the fur to return, but in the end, only a few long, coarse, iron-colored hairs grew across the naked skin.

Meanwhile, the animal's tail remained large and bushy.

"I wish your tail would share some its fur with the rest of you," Brook told the heavy kitten, washing it as it hung over her hand.

She began to touch the bare-skinned creature more, sometimes in order to incite Sis's jealousy, for Brook had grown deeply attached to the strange-looking kitten, while toward Sis, she felt little more than a blank. "Sis just can't be helped in her wildness," Brook told the kitten softly, touching its bare, large, hot belly. "She's not fun, either. But you are darling. We'll go to the vet, get some medicine for your skin." She lifted the heavy kitten, surprised how the animal seemed to reach out its arms to hold her neck. The kitten hugged her. It purred and needled

Brook with its claws. Its belly's skin lay against her neck and collarbone. When anyone, a friend or someone closer, had disappointed Brook, she recalled, it always felt like she no longer existed in some way, had become transparent, maybe had no organs of perception at all. Panic thrilled through Brook's chest, recalling it. "It's only a stupid kitten," she said into the creature's neck.

Emerging from the shower, she shooed Sis out of the way as the older cat shot past, skittish as ever. Brook sat on her blue chair then, phoning the Frinth Foundation of Life, rubbing her itching hands. "I want to know what's going wrong with this cat, and I want it fixed now," she told the woman with freckles and a suit, and described the kitten's unhealed wounds, and the dark, bare patches that had spread, now seeming to dominate the kitten's body.

"We did all the tests to show your kitten is fine, structurally, and ready to live," said the woman with the freckles and a suit.

"But she's *bald*," said Brook.

"Sometimes these animals have immune suppression. This is temporary and can lead to lethargy, fur loss, or eccentricities. But the kitten is fine. One thing you might do is give her vitamins — you mix them in a shake blended with avocado, which is extremely healthy for cats. Cats that don't consume avocados are actually nutrient-deprived."

"You're telling me to give my cat milkshakes?"

"Sometimes it's a hard adjustment to get a pet of this type, especially if it is replacing a pet that has died," the woman said. "You could consider writing in a personal journal or another healthy outlet to explore your feelings."

Brook hung up. Ten minutes later, she called the Foundation again.

"I'm bringing the kitten to your office," she said angrily, "and I'll want to see your veterinarian right away, with no delays."

4

The veterinarian's office had a separate entrance around the corner from the Frinth Foundation of Life's main door, but the two businesses were linked. Brook walked inside with her two cat carriers, at the last minute having decided that Sis should come to the vet, too, because in bringing both pets, she could prove to the doctor how drastically different the animals were, and how the replication process had cheated her. Even so, Brook thought, I would never give up this kitten, or reverse its birth. I love this kitten. The pets mewled loudly in their carriers, but grew quieter as Brook set them down in the waiting room. She saw a man in a white coat standing beside the front counter, which was piled with folders, and in her distress, Brook dashed to him, palms open, crashing almost purposefully into the man's chest so that she leaned on him, saying, "I don't know what I'm going to do if this kitten isn't cured!"

"Oh, well, now, you're not having a pleasant time of it, are you?" The man hugged Brook to him, and, reflexively, she hugged back. The hug continued such that Brook's mouth was covered by the man's coat and she could not reply, but the man's sympathy was so vivid that she cried a little. Then, still hugging her, the man said, his voice box vibrating at the top of Brook's head, "Oh, I lost a big white shepherd just a month ago. Do you know, it is painful when a very large dog dies before you, the body being so large and all, plus, in death, it expands a little bigger, so that you're looking at an animal much larger on the whole than an average pet, but just shy of the size of a small human being? It's disconcerting." The man drew back, and Brook saw he had round, red cheeks. The man said, "Do you want me to look at your kitten?"

"I can pay you extra, anything you want," Brook said, nodding, rubbing her face. "It started out as scratches from a cat fight," she said, "or maybe there were cuts from the glass apple." The man looked at her.

"That other cat, the adult one," Brook indicated, "she's wild. She shouldn't even be a pet." Both cats meowed intermittently. "But when the kitten started losing its fur, I got so upset!" she said, startling herself, realizing this was true.

"Of course you did," nodded the man. "That's a famous feeling!" He peeked into the carrier at the kitten, and his eyebrows rose infinitesimally.

"Is there any kind of medicine for her skin?" Brook asked.

"Well," he said, as if searching for words. "You know, lots of strange things can happen. Now, with people, we're self-regulating animals, you see. The body's systems regulate marvelously, and really, miraculously. It's kind of humbling. Yet, at the same time, it's amazing that things ever go right! And we mammals being nearly 100 percent water," the man added cheerfully, "plus, salt. Birds don't have saliva, you know. Isn't it funny to think that all our ideas and inventions and wars and all the consequences come from water and salt, in the end?"

Brook looked at the man, one side of her mouth grinning, for his words had calmed her. Beneath the white coat he wore a long apron, and stained tennis shoes.

"So you're the head veterinarian?" Brook asked, a little flirtatiously.

"No, said the man. "I'm a baker. They're having a huge luncheon here at the Foundation today, and we came to deliver the rolls. The meeting room's right back there," he pointed.

"Jesus!" Brook yelled, backing up. "Why did you make me think you were the doctor?"

"I didn't!" said the baker. "I — don't worry; it's okay." His red cheeks flushed redder.

"It's not okay," Brooks said icily.

"My name is Miles," the man said, as if this might make it all right. "I'm sorry — I may have led you on for a second."

"'May have'? Where's the vet?" Brook snarled.

"He might be setting out the rolls," the baker offered.

"Idiots!" Brook picked up the cat carriers, and Sis yowled. It was impossible to trust anyone. She could not stay now, in this kind of humiliation, in the erupting sensation that she had no ground to stand on. She was disappearing. She would call the vet later. Brook opened the door.

"You should stay and see the vet, Miss," said the baker. "The vet could help your kitten."

The baker, who even had a coating of flour in his light hair strands, who held the door open, who had just described for her the fragility and strength of life, made it hard — for there were still branches outside springing with green and flexibility in the winter wind — it would be hard to leave, harder to stay. Brook thought of her strange life at home with the cats, of the patience she exerted daily in knowing she was alone.

Sis yowled again. In the enormity of creation, how was it possible that there was only one Sis, terrified and feral, unique in the universe? One was not enough.

But it must be enough. Brook's gaze fell intently on Sis in the plastic cat carrier, who, even with her scared waxen eyes, possessed the light, unburdened bearing of those who are without guilt. Both cats, with their absence of speech and guilt, equaled dazzlingly unburdened creatures like birds and spiders too.

"Ah," Brook said, standing in the doorway, to the cats, and to her past acute disappointments. "Ah," she snapped into the air. "I hate you."

"I hate you," she said to both cats and the baker. "What will we do?"

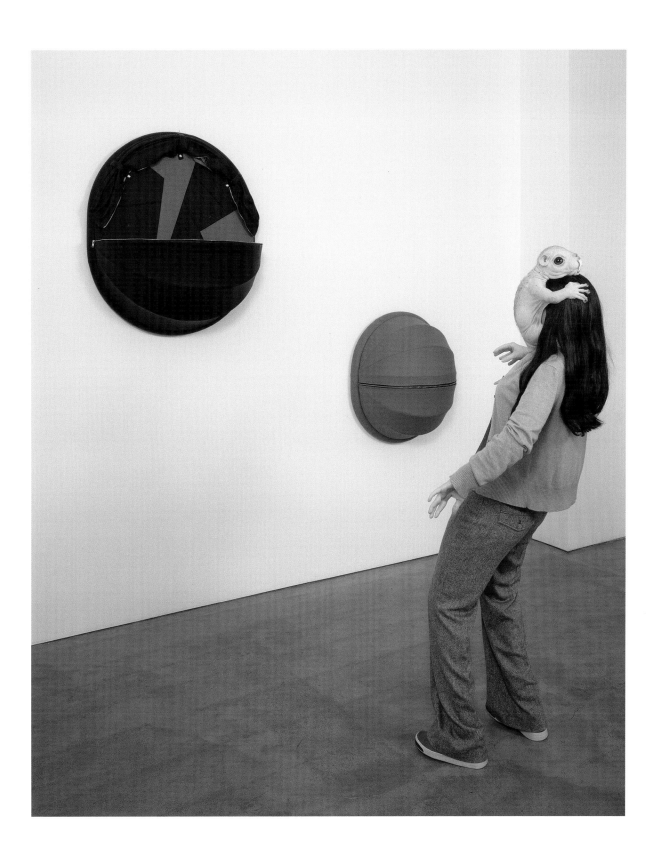

GABRIEL VON MAX

The Christian Martyr, 1867. Oil on paper affixed to canvas.

48 x 36¾ inches. Charles and Emma Frye Collection.

I can hear you, you know. "How come there's a woman on the cross?" you say. "Who is she?" "What's she doing up there?"

You sound surprised, even shocked. Perhaps because you imagine there was only ever one crucifixion. Or maybe you think it was a fate reserved solely for men. That it's not ladylike, somehow, to be crucified.

But then I was no lady. Just a mere slave girl from Carthage, on the northernmost tip of Africa — the city of some of the great church fathers, like Saint Augustine. Not that I was on his level, of course. My confessions would scarcely have filled a page, let alone a book. Among we slaves, the new faith offered not absolution for past sins but hope for the future — for justice, if not in this life, then in the next. So while our masters kept up their pagan ways, we lived — not that we had any choice in the matter — a simpler, purer life.

Mine would perhaps have been a long one if I hadn't been my master's favorite. That's why he took me with him when he sailed across the Mediterranean to France. But the winds were against us and the crossing took longer than expected, so we had to stop for supplies at Corsica, a rough mountain island with people to match. Even in your time, it's still known as a haven for renegades and pirates. And as fate would have it, we arrived in the middle of a pagan festival. A formal invitation was extended to my master and all on board to participate. A Corsican invitation — the kind you refuse only if you do not value your life.

You've heard of these pagan festivals, I'm sure. Your learned Victorian-era scholars had a fine time conjuring up mass orgies, with everyone acting out the fertility rites of the gods. It wasn't quite so, but the idea contrasted nicely with the moral purity of the church, so who am I to disillusion you? Besides, the orgiastic aspect is necessary to my legend, since if it was true, what could a good Christian girl do but refuse to participate? All the more since, per the requirements of sainthood, I was a virgin. (What would be left unmentioned was how any slave girl of the time — of any time — could possibly remain *virga intacta* when she belonged body and soul to her master. I don't think you need me to spell out what it meant that I was his favorite.)

It wasn't about virginity, of course. The demand that I celebrate the pagan gods was simply the last straw. The tipping point, you call it now — the moment that tipped me over into rebellion. I chose the next life over the half life of a slave. In death, I'd gain my freedom. This was my epiphany. The choice of death would be my first and last free act.

And so I became Saint Julia. Not Saint Julia of Carthage — even in beatification, they took my identity away — but Saint Julia of Corsica, the place I spent only the last few hours of my life. And when he painted me fourteen hundred

LESLEY HAZLETON

years later, Gabe would deny me even that identity. (That's what I call him, Gabe, because who can deal with such a Middle European aristocratic mouthful as Gabriel Cornelius Ritter von Max?)

He knew who I was. He visited Corsica in search of the artistically wild landscapes so in fashion at the time — the romantic sublime, it's been called — and discovered me *in situ* as the island's patron saint. So why call me merely "a Christian martyr"? Why condemn me to anonymity?

I know I shouldn't complain about this. It's not very Christian of me. But you know, even the greatest saints can suffer a touch of vanity. I hear it's been said even of Mother Teresa in your own time. Maybe a little vanity is necessary for self-sacrifice.

This seems a rather pleasant way to die, as Gabe shows it. That's why I can talk so easily to you now. I could be half-asleep, up here on the cross. I look quite at ease, feet daintily crossed — that is, they would be dainty if he hadn't painted them so big. I assure you my feet were in fact very well-proportioned. Though I do like the rubies set into the delicate gold-thonged sandals, just like those of the upper-class ladies whom I served.

There's something distinctly unladylike about how Gabe's posed me, though. Something almost trancelike. Something, dare I say it, of rapture. But then of course he wasn't really painting me. He was painting his mistress as she lay on the couch after they had, let's say, celebrated pagan rites. The sleepy eyes, the barely parted lips, the open thighs with the dark shadow between — it's the languid postcoital look. The erotics of crucifixion, you might call it.

Perhaps that's why he withheld my name; I can see that specifics tend to interfere with the erotic. If that is your interest in this painting, you really must forgive me.

Clever Gabe, showing me this way. He was only twenty-seven, and this image of me made his reputation. It's a tactic that still works. Paint a woman on the cross, and you send shock waves through what you call the art world. A very modern man, our nineteenth-century Gabe. A good commercial eye, you might say, for the outrageous.

But of course you do know that crucifixion was not exactly unusual. I realize how easy it must be for the faithful to imagine there was only one. The cross has become such a icon in itself — what you'd call a logo, really, the most famed and longest-lasting one ever — but the truth is there were tens of thousands of crucifixions over the centuries. So many that nobody bothered to keep exact count. The punishment not for regular thieves and murderers — too much trouble — but for people the authorities wanted to make an example of. People who challenged the status quo, that is, like rebels and runaway slaves and those who denied the power of the pagan gods.

"But not women," I hear you insisting. "They didn't crucify women. . . "

How sweetly chivalrous of you to think so. In fact whether Christians or Jews,

men or women, the cross was an equal-opportunity form of punishment.

You might want to cover your ears at this point. You might not want to know what it was really like. Gabe's painting of me was so popular, you see, precisely because it had nothing to do with the reality of crucifixion. Precisely, that is, because it appealed to the romantic imagination. It tastefully elevated sensuality to the realm of the mystical, eroticism to the heights of the spiritual.

In fact, of course, there was no romance. And whatever eroticism there was, it was strictly of the sadistic kind.

So if your nerves are delicate, you have been warned. The duty of even the most minor saint is to tell the truth, not to smooth it over. This, then, is what it was really like.

First, they tore out my hair — grabbed it fistful by fistful and wrenched it out of my head, leaving my scalp bloodied and raw. "Balding," your historians now call it. A standard procedure used to demean and humiliate prisoners ever since the Assyrians eight hundred years before Christ. You may remember it being used in World War II France for "collaborators" — women who slept with German soldiers — and later in Northern Ireland for women who slept with British soldiers. At least by then they used scissors and razors, however roughly. I suppose that's what you'd call progress.

Gabe knew about the balding, though of course he couldn't show it as it really was. There is nothing erotic in a torn and bloodied scalp. So he compromised. He showed me with my hair cropped in front, and left me a long tress to wind down around my back and into my waistband. Having it both ways, our Gabe.

And then they nailed me to the cross. Not on top of the highest peak of Corsica, as Gabe painted it — the romantic sublime in the haunting light of dawn — but in the most public and least sublime place possible: the marketplace. I was to be an object lesson: this is what happens to those who defy authority.

There was no flowing silk robe gently accentuating the swell of my breasts and the hidden crease of my groin. Instead, like all those crucified, I was stripped naked to the jeers and catcalls of the crowd. There was no handsome young swain reverently laying roses at my feet, the gods of the bacchanal forgotten in the light of my radiance. No, there was the crowd instead — the mass of people eager for the spectacle. Those eyes staring up at me were nothing like your eyes, so demure by comparison. Those eyes gleamed with perversity, alight with alcohol-fueled excitement. I could see the spittle in people's gaping jaws; the lip-smacking relish in the only female body they'd ever see unclothed; the lascivious spite.

I heard the hurrahs and laughter as the nails were driven through my hands (just a tasteful dab or two of blood for Gabe — you have to look close to see it on my palms, and the slightest smudge on my robe). Then the ropes were bound around my feet — not so loosely draped that you wonder why I don't just step out of them, but cutting tight and deep into my ankles.

And then the real pain began.

This was the point of crucifixion, you see. It was not merely execution; it was torture. Excruciating torture. And it was designed to last for hours. Hours, that is, if you were lucky enough to be weak. If you were unlucky — if you had the misfortune to be strong and healthy — it could take days to die on the cross.

I lasted through the afternoon and far into the night, to just before dawn. I would have let myself go if I could, but my body took over, instinct struggling for life against the will to die. Every muscle in me tensed automatically, trying to hold my weight so that I wouldn't hang from my arms alone. But eventually, inevitably, they failed. First my neck muscles gave way, and I could no longer hold up my head. Then my shoulders and back were stretched beyond endurance, and my arms were slowly pulled out of their sockets. And then, finally, the weight of my own body collapsed my chest, blocked my windpipe, and cut off my breathing. Yes, my body was forced to suffocate itself.

Need I say it was an ugly sight? Do I have to tell you about the sphincter muscles? Enough to say that they gave way early on, and in plain view of the whole crowd, and that when they did, the jeers and catcalls just increased until finally, tired of the sight and the stench, people wandered off in search of more pleasant diversions, and I was left there alone, half-dead, praying for the end.

Just another crucified slave girl, after all. Just another afternoon's amusement for the crowd.

Yes, I see you have had enough of reality. You much prefer Gabe's version of me, and I can't say I blame you. I'd love to have died the way he shows it — to have expired in a blissful swoon, my final breath sweet and gentle instead of a long, rasping rattle; eyes closed in rapture instead of staring wide open in terror; face serene instead of contorted in agony. This is the way we want our saints to be. Gabe got it right. The less you know about crucifixion, the more esthetic it becomes.

You really must excuse me, but I'm tired now. It's taken more out of me than I expected, talking to you about all this, across all these centuries. Time to gently close my eyes again, to sink back into my languid pose, to let your comments wash over me —

"Who is she?" "What's she doing up there?"—

Oh, the bliss of not knowing. The bliss. . .

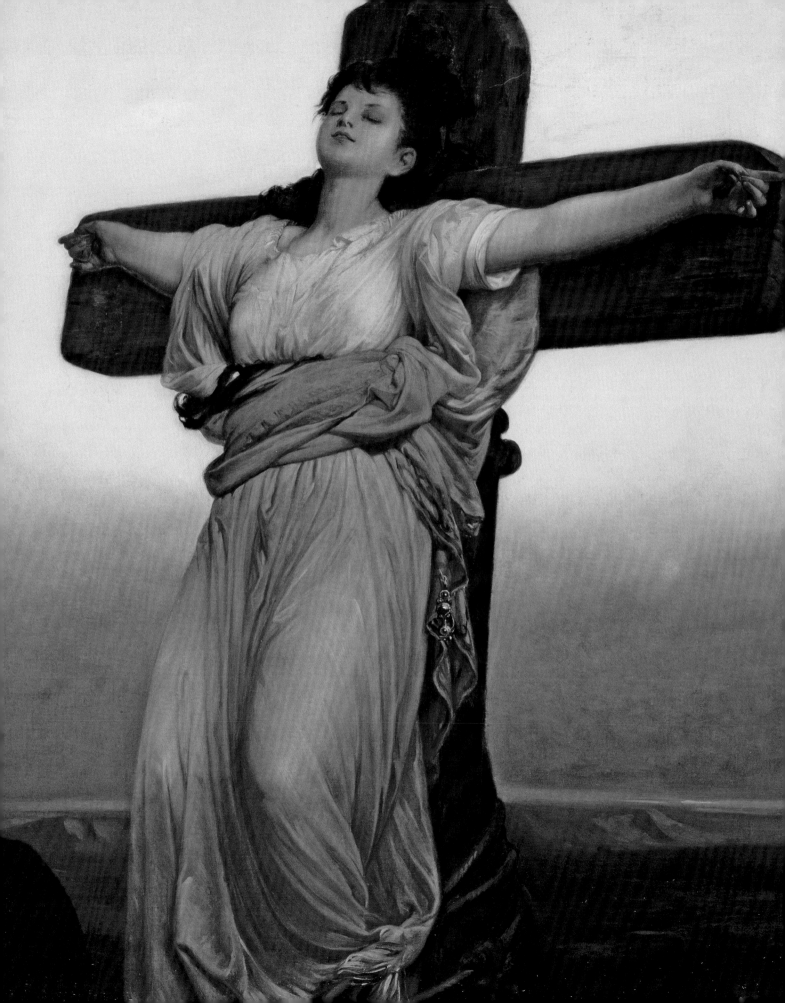

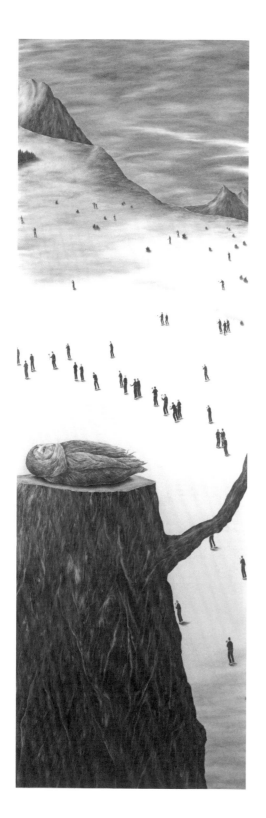

ROBYN O'NEIL

As my heart quiets and my body dies, take me gently through your troubled sky (detail), 2005.
Graphite on paper (5 framed panels). Overall: 165 x 59 inches. Collection of Nancy and
Tim Hanley and fractional gift of Mr. and Mrs. Hanley to the Dallas Museum of Art.

REBECCA BROWN

Once upon a time there were the Brothers. The place they lived was winter. It was always white and cold and always it was light. Despite the things the Brothers did, that never should be done at all, but if they are, done in the night, in darkness and with furtiveness, the Brothers did them in the broadest light. Perhaps it was their nature.

Around the place the Brothers lived there was a mountain range and hills. But nobody ever went there, at least they never went alone, for if they did then they did not come back. Although the Brothers seemed to not remember this. The Brothers remembered many things, but others they forgot.

Once upon a time we all were Brothers.

Always it was winter there, the light was always winter light, abrupt and sharp and brittle, in some way beautiful, but also with a glare so everyone had to squint. It was as if, as bright as it was, what they were seeing was not what was. It never darkened, was never night, despite the things the Brothers did which should never should be done at all, but if they are, done in the darkness and with furtiveness, with shame, without a heart. The Brothers did these things though they were brothers.

Always it was light and it was brilliant almost blindingly. White snow covered everything and everything looked crisp and pure, unsullied, clean and fresh and sounded sort of like that too. That is to say, it sounded very quiet, soft and muffled. The sound of the pad of your feet was a tiny swish, like the sound of the paw of a careful cat, you almost couldn't hear it. The sounds were the sounds of snow on needles and branches, of snow falling in air, a sound of whiteness, less than breath, the sound, almost, of nothing.

So quiet you had to work to hear.

So hard to hear, the Brothers stopped listening.

Then didn't hear at all.

Perhaps this was their nature too.

There also was an owl. She lived up in the trees, where she would look and sigh and shake her head, which sometimes shook the snowy branches and the snow fell down. If someone was below the tree, he might look up, but mostly no one did because the Brothers were busy. On the one hand the owl tried to stay above it all, away from the things the Brothers did, for she could not prevent them, but sometimes she couldn't help herself.

"Who?" said the owl. "Who? Who?"

But none of the Brothers answered her.

Then, pleadingly, as if with tears, "Why? Oh, why?" said the owl.

But same thing: no one listened.

Sometimes, also, the owl said, "When?"

But they ignored her.

The owl wasn't happy but didn't give up. Though she was more or less just talking to herself, dithering nattering blubbering on like a lunatic a bag lady a no one who nobody listened to, she kept asking. "Who?" "When?" Because who knew, the owl hoped, if that's not too strong a word, one day one of the Brothers might.

Maybe because they always had or because they thought they needed to or maybe it was their nature, the Brothers did the things they did. Or maybe there was no reason at all, as if it was the nature of everything.

Always it was winter there and always the Brothers did the things they did. Some of the things they did weren't much: they stood around and wandered around. They walked back and forth and around. They sat around and folded their hands. They met for meetings and processed, discussed, debated, input stuff. (None of them had to listen to do any of this.) Their eyelids drooped, they slouched, they napped, they snored and snoozed and thought up other things to do.

Some of these things were nothing almost.

But some of them were not.

Some of these things were terrible.

And some of them were worse.

One day, a day like most of the rest, the Brothers were doing what they did. They were gathered, in their team or circle or collective or mob, around one of their Brothers and they were kicking him, beating the shit out of him. He was crouched on the snowy white pretty ground and he was begging them, he was pleading with them to stop, which none of them heard, of course. They were throwing stones at him, big ones, really huge ones, for beneath all that pretty white muffling snow, it's a nasty, gnarly place with huge big nasty rocks. They were knocking the guy around, clawing his eyes out, strangling him with their bare hands, crushing his Adam's apple with their sports shoes, breaking his teeth and ripping out his tongue. They were garroting, flaying, disemboweling and, via this device they'd ingeniously devised out of some boulders and logs and other stuff into a kind of lever or fulcrum thingy, tearing, via his cartilage and soft weak connective tissues, him limb from limb. They were stringing him up by a rope and hanging him from a tree.

The thing that made this day not exactly like most days was that this day one of the Brothers, not the poor bastard getting it (beaten, stoned, disemboweled, etc.) but one of the ones who was giving it to the guy who was getting it, got this weird feeling. It was like there was this brush of air alongside him, like the side of him was suddenly cold — well — colder. Sort of a little breeze, but not even that. Nothing as substantial as air. Something less substantial. Maybe it was something *in* or *on* the air, this thing without substance. It was like this *not*-thing approached the side of his head, then went *near* his ear, then *into* his ear. There was a tickling in his ear, like a bug got in, then a fluttering, a buzzing. He slowed down his garroting, flaying, etc. Not so much that the other Brothers would notice. He knew, as all of the Brothers did, to never, ever do that. But he slowed enough to pay a kind of attention he had not paid in ages.

Then he felt like part of him was back from somewhere else but he wasn't sure where. Like something was just a tip of a tip away from the tip of his tongue but he couldn't remember. Then his arms were suddenly heavy and it felt painful — physically, bodily painful to keep doing what he was doing to his brother. Our guy's arms dropped to his sides like they weren't his own, like he was a gorilla or doll or a zombie in a bad B movie. He stood like that and stared like that, like there was something wrong with him.

Then it was like he was seeing, actually seeing, for the first time in his life, what he, what he and the Brothers, his Brothers, were doing physically, bodily, painfully to the other guy, their brother.

After our guy looked, really looked, at the guy they were doing it to, he realized what that cold, tickling sensation at the side of his head had been: he had *heard* something.

Had it sounded to him like, "Who?"

He didn't remember.

Like "Why?"

He wasn't sure.

Like "You?"

Our guy forgot.

Had it sounded to him like "You?" Had it sounded like "You."

The brother stopped and stood and looked and listened. Snow fell down as if from a tree above. He cocked his head like a dog does when it's trying to hear something far away. Then very, very cautiously, so as not to draw attention to himself, our guy took a little step backward. It was just a baby step, but with it, he heard, beneath his body, the swish of snow, the crunch of the crust of the top of it, the fall of snow from a tree. Then he took another step and he heard his own body, his pulse and his breath, the way his eyes were trying to blink as if to get something out. He took another step away from the mob of Brothers and poor

bastard, then another step, this one bigger, and then he heard the guy. He heard the poor guy's racing pulse and his panting, gasping breath. Then our guy took another step and he heard the mob and everything they were doing to the poor guy. Then our guy took another step and he was out of the mob and he was running. He ran away.

The Brothers, who were so busy beating their brother to a bloody pulp, didn't notice that another of their Brothers, our guy, had turned away and gone.

Though probably the only one who might have noticed anyway, because he was facing him, was the poor bastard they were doing it to. But the poor bastard was trying to hold his hands over his head as if to protect himself, crouching down and trying to turn away as if to escape the stones, electric prods, skewers, etc., which he, of course, could not escape. So I doubt the poor bastard noticed our guy but maybe he did. Maybe it would have been nice to see, before the final blow that knocked his brains to smithereens, a vision that one of his Brothers had stopped doing what the rest of them were and had turned away from that.

Our guy had turned away and run. And as he ran, he heard more things.

It's not exactly quiet when a gang of people is beating someone to death, but oddly enough, while our guy had participated with his Brothers in doing these things, he hadn't heard what he, what they, were doing to anyone else at all. It was like, while he was doing it, the whole thing was a TV show, a docudrama about some place long, long ago in a faraway land *and* with the sound turned off. It was like our guy had been — like all of the rest of his Brothers? — watching what he was doing, what they were all doing, but not really seeing it, not hearing it, not even *doing* it. It was like someone else was doing it — no, not even that. It was like *no one* was doing it, like it was *just happening*. As if all by itself. And it was like the guy they were doing it to, like all the other guys they had done it to in the past and would do it to in the future, were not quite real, not even human, and certainly not Brothers. Except they were. They *were* Brothers. They were all Brothers.

But then, as our guy turned away, it was like the mute on the remote was flipped off and he could hear, and more with each farther step away, the volume turned up. It got louder and louder the farther he ran, like he had developed some weird kind of Superman x-ray vision thing, only à la hearing, and he could hear — could not *not* hear — the astonished surprise of the other guy, then the pleas and the cries of the poor bastard, his panting breath, his racing pulse, the smack of each and every stone against his skin, the jab of his skin, the tearing and lacerations and the pooch of the first push through of blood, then every single drop and then the course of it, the mess of it, the crack of bone, the squish of the guts, of the viscera, the gurgle in his throat, him trying to beg, then further smacks of stone, of fist, etc., each willful, cruel and wicked, each terribly thought-through, murdering thing the Brothers did.

Maybe our guy was trying to outrun it, but he couldn't.

He ran as far as he could then he came to a hill.

Nobody ever went to the hills. At least nobody went alone.

But our guy had, in fact, been to the hills before, but only with his Brothers, not alone. He'd been there with the mob of them when they were chasing after some other brother, somebody who had, unnoticed at first, as unobtrusively as he could, so not to draw attention, stopped doing what his brothers were doing and run away. Then after the Brothers had finished up with the first guy they were working on, and someone else — some ones, that is, not ever one alone, but only a group a gang a bunch — did notice that some *one* had gone away and then went after him.

Our guy knew all this somewhere in himself. That is to say, he'd known it once but then forgotten but now remembered. He knew his Brothers would come after him. He knew what they would do.

He also knew that it would take a while for them to finish up what they were doing with the poor bastard they were already working on, so our guy knew that if he hurried, he could return and be back in among his Brothers before they'd noticed he had gone. He could, thereby, for the time being, save his skin. He thought of this a moment. He sat beneath a tree to think. Our guy had run a lot and was tired, beat almost, and he was hearing his racing pulse and weary breath but also, though he was far above it now, the sounds of the poor bastard getting it: his racing pulse, his weary breath, the terrible things the Brothers were still doing to him. Our guy held his breath to listen more and that is when he heard those noises stop. The guy, not ours, the other one, had breathed his last and there was nothing. For a second our guy thought he'd stopped hearing again, the way he hadn't heard before, but he was hearing, he was hearing that weird, postgasp silence, a real silence, different from the pseudosilence that he and the Brothers had heard or not heard in their not-listening. This silence was real, it was a thing itself. It was the sound of someone being dead.

Our brother dropped his head into his hands and wept. He wept and wept and wondered who the guy they had done it to was. He'd never thought of that before, who any of the poor sods were, the ones they did it to, if they had names or what color hair or eyes they had, what made them different or the same as the other Brothers, what color skin, or fat or thin or if he'd ever loved or ever had a name.

"Who?" he wondered out loud to himself, who was that guy?

He didn't know. He realized that one of the reasons he didn't know was because he'd never asked. He'd never asked another brother many things before. Then our guy realized that even if someone had tried to tell him long ago, he would not have heard. Maybe the dead guy or one of the many dead that he and his Brothers killed had tried to tell but no one listened.

"Who?" he asked himself again. "Who? Who?"

Then our guy wondered more.

"Why?" he cried out loud. Why had he and his Brothers done these things? Why did they do them yet?

And then he wondered how he could.

"Me?" he wondered. "Me?"

His face was in his hands and he was weeping.

Our guy was in the snow beneath a tree. Above him in the branches was a rustling like something was moving or had been there and had flown. Our guy looked up. He looked up at the branch where something was but was no more and wept. He wept for what he'd done himself and what his Brothers did. He wept for what the Brothers did as willfully and cruelly, as wickedly and terribly as if it was their nature.

I said earlier that for a while the Brothers didn't notice our guy run away but that was only for a while. But then they did and they came after him.

Our brother heard them coming from behind. He heard their stamping feet, their eager breath, their grunting, happy cries.

He knew, because of how he'd been, that nothing he could say or do would stop them. He knew that nothing he could say or do would change them.

He did not know why he had changed. Why had he suddenly, surprisingly, as if with grace, heard things that they had not? Perhaps it was his nature.

He sat alone to wait for them.

He knew they'd be upon him soon and do what they would do. But maybe, our guy considered, or even hoped, if that is not too strong a word, one of the Brothers wouldn't. Maybe one of the Brothers would slow or stop or for some reason no one knows, hear something, in the winter air, and change.

He waited for them differently, as was his nature now, with pity and forgiveness for the things that they would do.

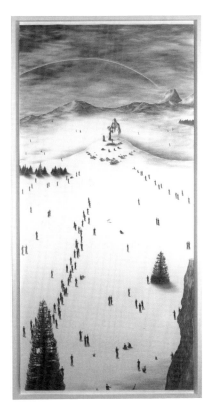
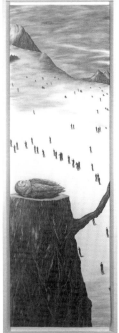
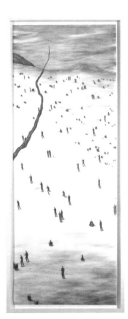

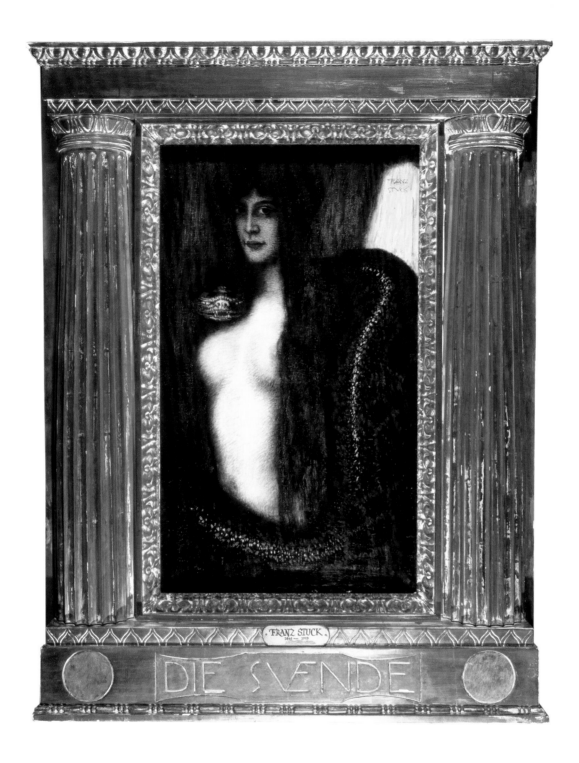

FRANZ VON STUCK

Sin (*Die Sünde*), c. 1908. Syntonos canvas. 34⅞ x 21⅝ inches.
Charles and Emma Frye Collection.

ALTAR-FRAMED COBRA WOMAN, UP HIGH

FRANCES MCCUE

Sin: the conversation
We begin with the wind.

I

A word about M_____. Since she took us
from our home and chased us to the station,
then to the other station, through the pasture,
to the town beyond the towns
we'd known, shooed us to the hinterlands
where we stood at the silo, where the train crossed,
until the chase, hounds and all, tore past —
M_____ in the shoot — her red coat and spurs alight,
we waited outside Stedman's Mercantile.
Where, shorn from our city wardrobes,
we stood on one foot and then the other.
All that time.

II

We should have known, righted ourselves
and narrowed our gaze, taken watch before
the journey, but M_____ did not hoist
serpents or pull her bodice away. Not then.
Upon her whim, she'd run us from her rooms;
we obliged. We pulled our fingers from the velvets,
unhooked them from the tea cups,
let go of the tassels, traipsed far beyond
the fringe of streets — hoof slogged — and chamber pots,
beyond the muggy stench. And dust,
scraping, scraping at the jambs.
Farther on, the countryside bloomed
and the quiet overwhelmed.
No tinny clouds or wind singed with grit
to pave our throats; along the lanes, dogs and cats
alighted on the stoops and did not die of breath.

We found our way clear.
Into a place, where our conversations turned on wind,
how it toppled trees and tore through grasses, rather than;
we learned to rub each other's backs.

III

M_____ flung us to the villages;
and on the run, M_____
was a flan: a pudding undercooked
and no one would speak of it.
Once caught, her chest puttied, the woman was
rolled in dust, fattened like a hen, wedged
forward, her spine concave.
Skin furry with brush strokes.
Those were the first days:
her mane, drop-fleeced around
her and the gown pulled aside, aspiring cobra —
a spike in the eiderdown, gleaming there
amidst feathers. Scales grown upon her skin.
Heavy leather pushed in.
We knew that underneath, she was mean.
Meaner than we'd seen.
We mounted the altar up high. Affixed the frame,
blew ourselves a wish: that adoration
would draw muster, be enough to capture her.

IV

Sin, we learned from M_____
congeals in craft and ornament:
lampshades of human skin, pricked
with lanyard strings along the seams; or
sketches of those girls, lippy
in the killer's journal. Residue.
Instead: virtue strings the clean
pluck of sloop to wind, leeward —
Clickity that. Clickity that.
Our feet unstuck. Set free
of the crossing, that rail-tie,
that pavement, that silo smear
and glint against the feedmill.

V

One minute, you're chased away and
later, you are picked up

and carried across
that river you couldn't
walk upon yourself

When God held me in the palm of his hand,
you were thinking superheroes or Gulliver
but I felt wicker with cushions. That squeaking,
the straw pushed down,
with a yolk blown behind me, light
one couldn't see by.
Men with sparklers, I thought.
I was safe there, held with my wounds scraped out.
Packity, packity was the sound,
the ice going in and cotton sealing.

Set upon the skin of God's, I saw below us
the world of bald-faced nurses, little medicine cups
upright on their palms, taking rounds.
I was another version of the pill, set upon a hand.
Tucked in. A small thing cared for. Held up.
Studied closely, like a seedling.

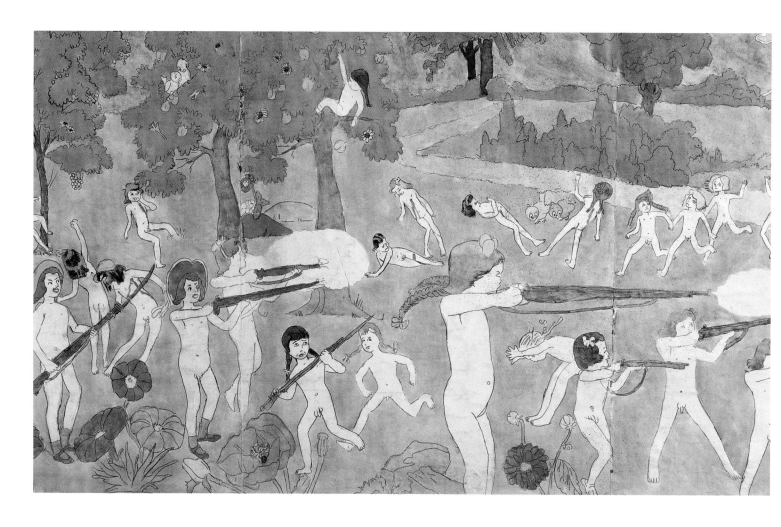

HENRY DARGER

Untitled (Battle scene during lightning storm. Naked Children with Rifles; detail),
mid-twentieth century. Watercolor, pencil, and carbon tracing on pieced paper.
24 x 74¾ inches. Collection American Folk Art Museum, New York, gift of Nathan
and Kiyoko Lerner, 1995.23.1b. © Kiyoko Lerner. Photo by Gavin Ashworth.

EPISODE 11: BATTLE!

. . . the fiercest and bravest of these, her blonde curls bouncing as she leaps toward a villain, runs a sword through that dastardly heart. All around them, pitiful cries fill the air, but with his final resounding howl, a coward's bellow of surprise, thick hands falter, and evil deeds, in one great unfastening, unravel. Yet the innocents, their poor little sunflower bodies racked asunder, cannot be revived and made whole, and even while those stone-hearted scoundrels fall back astounded, a mighty. . .

EPISODE 4: FIRE!

Eight blocks away was an abandoned tar factory where kids played from time to time. It wasn't one of the regular spots like under the metal bridge at the dead end of Taft Street or the weedy lot behind Dexter's Market. But now and then on long summer afternoons when heat stilled the streets, a ragtag gang found themselves drifting to the narrow alley beside the factory. They snaked between close walls streaked with urine from the bums who sprawled there at night and, at the alley's end, scrambled up onto a half wall and over a locked metal fence to enter the factory's walled inner yard.

There was, with them, a tall boy named Jack O'Dignan, and he brought along his younger brother, Leo, who did not speak. His tongue, Jack said, had been notched, nearly cut out, after an open-mouthed fall from a second-floor window, which everyone knew Jack himself had initiated. Doctors had managed to sew the tongue back, but the nerves were clipped, and Leo could only flap it uselessly. And with them, too, came two other little boys no one knew well, although they had been seen behind Dexter's, scowling and picking fights with Dexter's three-legged cat. They claimed they'd taught it to spit. No one much cared for them, and once, not long ago, someone had paused beside the unliked boys' fallen bicycles to press found tacks into the front tires. Helen from next door also came along — Helen with her scabby knees and cool defiant expression. Underneath the collar of her blouse, she wore a chain with a Saint Philomena medal that — as she told Margaret Breen in greatest confidence — the Bishop himself had given her. No one asked the last fellow to come, but Helen was there, so he felt okay skirting the edges, until those bully boys set at him and ran him back through the alley, banging his bare legs on the brick sides as he went, and Helen not saying a word for him, only gazing at the white-hot sky above his head.

ADRIANNE HARUN

Boy, was he mad!

Of course he crept back. Exiled, he spied from the alley as the other children explored that private stolen place. He squinted as they popped fat tar bubbles, and he plotted even while Leo eyeballed him and Helen wandered the asphalt yard, princess-like, picking up lobs of softened tar, rolling them into balls, then laying a line of 'em on the concrete ramp leading up to the locked factory doors, as if she were amassing ammunition for a coming battle.

Hsst. . . he tried, but she would not hear him. *Hsssst. . .*

He waited until she was closest to the alley, her best chance, before he started just a little fire with pieces of trash those bad boys had thrown heedlessly behind them. A hellish day, so hot the tar melted on its own, and as the fire took hold, the air seemed to recognize it and draw it more and more passionately to itself until, together, the fire and the tar and the desperate air raced down that alley to where those bad boys conjured their play.

Hsst, he tried once more for Helen. As loudly as he could before the walls began to crumble in and a great wave, a searing sheet, flew away from him, and he ran and ran and ran. . .

EPISODE 15: IN THE MUSTARD FIELDS, A RECKONING

One Tuesday, word came that a tremendous row was brewing. A clothesline hung with children's dresses — yellow dotted swiss, sprigs of forget-me-not on pale pink, mint green seersucker with lace-edged puffed sleeves — was chosen as the battle site. The clothes created a long curtain separating the back of a single house from the mustard fields. Weapons were chosen for what promised to be an occasion of terrible violence and inescapable confrontation, the likes of which had not been seen before that time. Yet when the precise moment arrived and the horrible advance commenced, the row of girls' dresses came alive, wind entering their skirts, billowing out sleeves, so that the dresses marched in the lightest fashion, and that very gentleness, relentless and unstoppable, confused the enemy, who set forth massive charges of great fire that the wind blew back toward them. And still the little girls, vacant, headless, continued their own advance. . .

EPISODE 6: A VIOLENT STORM DESTROYS
CALDWALDER AVENUE AND MOVES OUR HERO
FROM ONE WORLD INTO ANOTHER

He could feel it first — a burden so heavy the air itself ceased to move. A moment of stillness so complete it could only register as terror. Open-mouthed, not a one of them could offer a single scream, not even as the legions gathered, the flash from their weapons piercing the sky, their whole sulfurous world upended.

Had days passed? Or years? Or was it mere hours before he came awake in a long narrow room with tall windows, their sills too high for a child to reach. Only the sky visible, restored perhaps, but crueler and more distant. The hard bed bruised; the air was soaked with urine and vomit, those twin stenches of despair. Constantly, the rough boys promised each other, then delivered, dire retributions for their crimes, which were many and unspeakable in their horror and, in the end, all his. He compiled weapons — a sharpened stick, a bundle of putrid rags — beneath his thin mattress and held his breath as metal carts rattled the halls at night and muffled screams vibrated through the plaster walls. The Ones-in-Charge were careless in their evil. Blood stained their shirtfronts; they wiped it on the walls. The stench invaded every inch of air, so that the remaining prisoners breathed death and ingested it in with every forkful of boiled food until they too began to rot from the inside out, and the child killers only smiled, their victory nearly in hand. . .

EPISODE 1: CAST OUT INTO LIGHTNING

We can advantageously begin our story in the middle of everything — in the middle of the night, in the middle of the battle, in the middle of a tremendous lightning storm, whose bracing strikes flash relentlessly across a black sky. For here is the moment when all trepidation and patient waiting have been cast asunder and we go a'wailing into the belly of our own fears. Has anyone ever been so brave? Has any adversary ever been more dastardly? In the middle, fear and courage hit their zeniths, riding in one twining, unbearable twist. In the middle, it's not at all clear that an end will ever come. The middle is the darkest, narrowest channel of despair; the widest river of hope. Pray our story may continue.

EPISODE 10: A HEROIC JOURNEY OF EPIC LENGTH

Barefoot, with welts still stinging, his head ringing from a beating, he escapes! He silences the trembling door and heedless of what lies ahead, plunges into the fields. The sharp edges of broken corn stalks slice his tender skin so that when he reaches the gravel road, his feet are bleeding. He is a martyr; he is being martyred. Hobos bearing bindles come upon him and, seeing his wounds, pause to contemplate him. He is ready to die and who better to take what little he has left? He empties his pocket of his solitary coin, kept secret all this time, and offers it to them. But one of 'em tucks it firmly back in our hero's pocket, while another lights a cigarette, "twists a dream," and smokes it, staring at him.

 "Take him to the camp?"

 "Uh-yeah."

 And, great boy that he is, our hero is lifted on both sides and half-carried down a woodland path to the rails.

"Who's this?" The call goes out as they reach a clearing.

"A member of the Brown Family," his hoboes, the ones around whose shoulders his arms are draped, answer.

They call loudly for Graveyard Stew, which, when it is handed to him, turns out to be campfire toast and hot milk in an enamel cup. He can hardly eat for weeping; he is so grateful, though his poor feet throb.

"This lamb has been to the Hotel de Gink," they surmise, checking out his institutional rags, the too-thin shirt, knickers worn gray from washing, "or the little school."

"Ain't there a nuttery up theres a'way?"

"Poor lamb's padding the hoof." They gaze at him with something resembling affection.

"And he tried to slip us his last thin one?" His generosity astounds them. A call rises up, and change rattles into his empty cup.

"Have you somewhere to go?" he is asked.

He manages to gulp out "Chicago," and they cheer, because this they can do.

"Put him on a side-door Pullman," they agree, and before he knows it, his poor feet have been bundled up in nearly clean rags and stuffed into a pair of shoes that have only the memory of soles, and he has been thrown, not ungently, onto a slow boxcar heading northeast back into Chicago, his pockets heavy with their own thin ones, two almost-handfuls of coins — enough to get him on a streetcar to the old neighborhood by St. Anne's, enough too for a couple of hot suppers in a corner diner.

"Don't get yourself sloughed," they admonish him.

No longer a martyr; he's become a hobo's angelina, on his way home under protection. Except there is no home, and his journey will be far longer than any of them anticipate, and what will come next will. . .

EPISODE 24: THE LITTLE SISTERS OF WRETCHED MISUNDERSTANDING

They are not little; they are not sisters; they are not girls; they were never girls. They kidnap soft-eyed beauties, wrapping them inside their habits. They become the girls' own prisons, the only hints of their presence a delicate cheek beside the harsh starched edge of a wimple; a peculiar rapaciousness in the eyes while watching the play of children; a capacity for bravery beyond what any true contemplative might attain. The imprisoned girls are the only hope the Sisters have of being saints themselves, so those monsters refuse to release them wholly, merely allowing glimpses of their terrible tortures to appear in hands chapped raw by dawn scrubbing, in open sores along the wimple-bitten neckline, in the sorrowful bowing of shrouded heads too heavy to break free.

This tiny room is crowded with a dozen conversations. Proclamations are handed down; oaths sworn. The constant huzzah of threat. He holds his father in the palm of his hand and whispers to him that he, his sole surviving child, has been stolen. Whisked from their evenings together, late editions of the paper spread on the kitchen table, a fried egg, the father's broad hand on the boy's head.

He has been stolen. Locked away, he tells his father, one of many child slaves. He would give his father directions, but who could find this prison? Who could find any of the lost children, except perhaps other vanquished children? They have been so clever, stealing a reed-like boy with avid eyes and quick facility. An able, hungry child, whom they hid in this old man, shambling in his long coat, heavy in the heat, itchy but whole.

Should he cry out? Should he weep loudly in consternation. In the beginning, he tried, declaring himself in whatever small ways he could. *Kuk-kuk-koo! Kuk-kuk-koo!* An age-old cry to battle that fell on deaf ears. He explains himself to his father, who knows what it's like — to be trapped, to be stilled. Men's voices, drunk and belligerent, invade the hallways of his childhood. On the streets, a woman clangs a pot, warning them. *Kuk-kuk-koo!* A policeman's whistle, the trolley car rails hissing, and yet it is he they must silence.

This will change. The weatherman is nearly right. The sky will empty of clouds, then in the next breath, will hang heavy and gray, a soiled sheet spread from one horizon to another. Wind will tipple, a soft grazing, before erupting, barreling through streets, churning and churning until wood gives way, until bricks crumble. It will rain and hail and snow and then begin again.

Until then, the girls ring around him in that endless night. Such glowing cheeks, such graceful elfin beauty. His dank gray room is enveloped in fairybook yellow and a consecrated scarlet, in the redeeming blue of Our Lady's gown. When his head droops as he courts sleep in his chair, he feels their tiny hands embrace his own, and their chatter, like birdsong, begins. Their voices fill him — they are his balm — and he rejoices in the scenes they reveal. What a crowd they are and how free! Their perfect naked bodies sloughed under a gentle rain, the sun behind it, the sky filling with majestic winged creatures. One world cracks, and beckoned, he steps through and is free once more.

EPISODE 15: OUR HEROINES

They are so astonishingly pretty. Their dimpled knees. The sweet, soft forearms. See how, even at the direst moment, the one that would make a grown man blanch, they skip, they frolic. And, oh what a scent they give off! When those gallant girls pile together on the pavilion to sleep, the misty rain obscures them, and

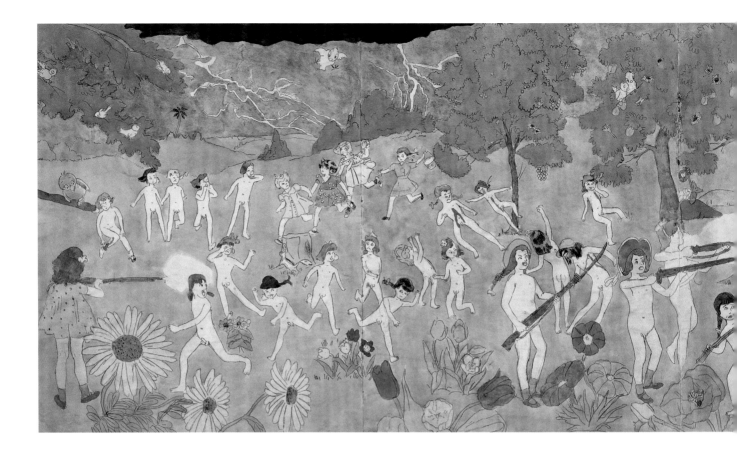

a peculiar perfume haunts the woods, misleading any predators. It is the scent of salvation, he reckons. He can barely stand it.

EPISODE 41: TANTRUM: AT WAR WITH GOD

A bucket upends. A broom handle catches itself in a door jamb and hits his chest like a man's fist. He is lectured, chastised, coldly repudiated.

God-damnit!

His pocket linings unweave themselves, unseaming tiny passageways for his few coins to slip through and fall soundlessly into the gutter, becoming someone else's luck. What creatures infest him. How they undo all that is holy in this world. His hate for them cannot be contained.

God-damnit!

Jesus Christ!

His name is rage until he remembers that if he bares his chest — which he won't — the Lord's banner is his own heart's tattoo.

Sacred Heart of Jesus, Pray for Me, Poor Sinner That I Am.

His rosary beads are plain black, worn gray on one side from the three mysteries:

Sorrowful

Joyful

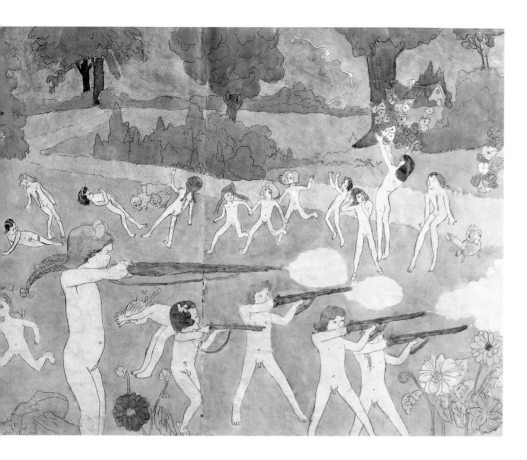

Glorious.

Every step he takes should be in imitation of Christ. His suffering belongs to this common little man. His resurrection the man's promise. A failed promise.

God-damnit.

He fails. Again. Again. He could slice his own heart clear out of this traitor's being even as His banner is raised again:

Sacred Heart of Jesus, Pray for Me, Poor Sinner That I Am.

EPISODE 52: BLIZZARD!

It's gone — every scrap of this soiled world, even the noise. No streetcars can run, and if someone has picked an argument, the snow has covered that as well, muffled it in drifts. Who could believe how thoroughly every problem has been solved, the world sleeping, its pain buried and out of sight. He has never imagined such desperate impossible beauty — the cold *snap!* — yet he is beyond weeping. Pure exhaustion greets this thrilling disappearing act, because, even as the snowflakes slow, the thought possesses him that peace is nothing but another form of capitulation, one more slow-ebbing away.

Do what you will; it's too late, he tells those who come to tell him the world will be remade once more. How astonishingly weary he's become.

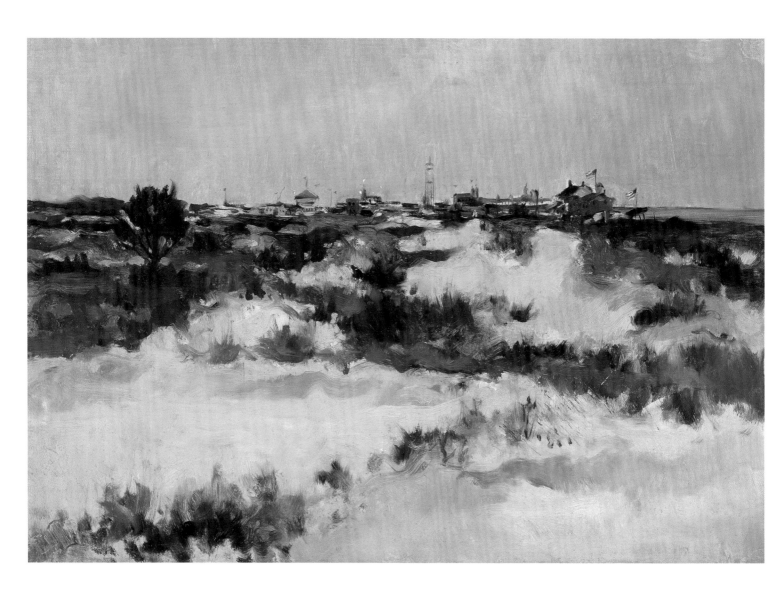

JOHN HENRY TWACHTMAN

Dunes Back of Coney Island, c. 1880. Oil on canvas. 13⅞ x 20 inches.

Frye Art Museum Purchase, 1956.

The flags beyond those dunes are roaring.
Carnival here. Freaks for the fun of children.
Taffy and games. Beyond the din, the sea
compounds the joy. Ships go by,
plenty of fuel and no destination.
Beyond the sea, you feel, people are living,
happy and loving, no hymns or diseases.

You cannot cross that sand to the fun.
That friendless grass prohibits what chance
you might have to shake phantoms of lust —
two women fighting over your body,
the loser to love you, the winner to die.
They always fight dirty in dreams,
You always hear the games in the wind.
You are never closer, forever held back by the sand.

Someday you'll cross it, enter the gate
of the gayway, win all the money,
eat yourself sick and come back relaxed
to these dunes, and here find your bones
friendless as grass, covered with laughter
and flags the seawind tore from the poles.

ONE BY
TWACHTMAN
AT THE FRYE

RICHARD HUGO

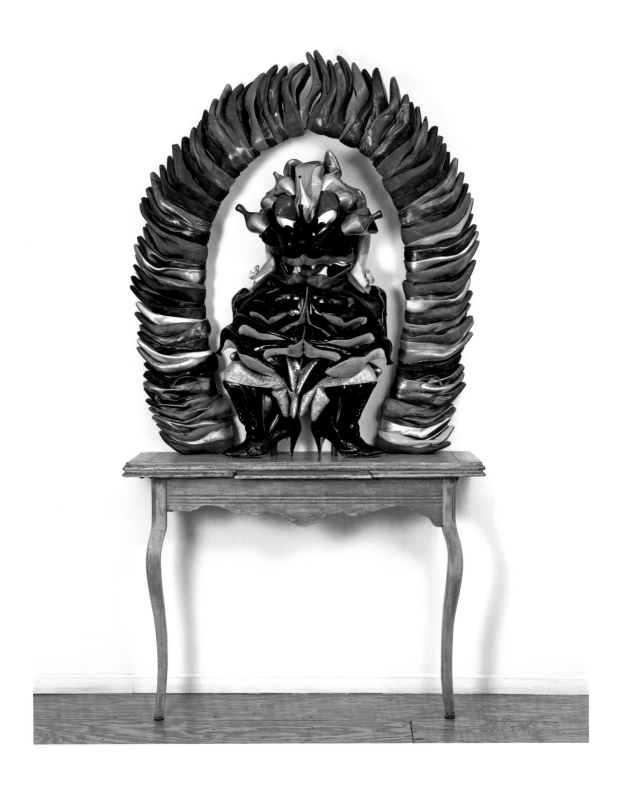

WILLIE COLE

Sole Protector, 2005. Shoes, PVC pipe, painted wood table, metal, and screws.
80¼ x 44 x 15¾ inches. Courtesy of Alexander and Bonin, New York.

HIGH-HEELED SHOES

PETER PEREIRA

She digs high gloss,
gold soles. Heedless,

glee-less she glides,
she sighs. He sieges,

he slides — hiss, hie —
he ogles, he hides.

She shields hose's
holes — does he see

leg, see heel?
He elegises, he

lies — O godless god-
dess, his ego she oils.

He sidles. She idles
She dishes. He dies.

Having is a kind of halving.
Salving a kind of saving.
Appealing's not far from appalling.
Only our ruinables are insurable.
It's up to you whether the world
ends in pleasure or erasure,
rapture or rupture. Whether pain
leads to gain, and rain to grain.
Whether these lines produce vines,
or wines, curses or cures.
My file is not my life, he said.
As if a belief's all one needed
to make something feasible.

THE FEEL
OF FELT

— (A)versions of the Pledge

I pillaged elegance at the flog
of the Untied Tastes of I, Camera,
and to the Epic Blur for switch it hands,
aged innuendo or not, invisible id,
with Injected Salubrity for all.

★

I plied a glee glance of that leg,
the Nudist Estate I am a force of,
and to the Pub Relic daft with rich sons,
genuine or not, a blinded division,
with Jubilate Stridency for all.

★

I plea ignorance to the fad
of the blighted hates of America,
and to the repugnance for its bloodied
journalists, its intwined adultery,
and defective bullshit incising all.

★

I pledge Allergy to the flame
of the United Station Wagons of America
and to the Repulsion for which it stands,
one nausea under Gold, indivisible,
with License and Juvenilia for all.

★

I plot Allegiance to the flag
of the Unkind States of America
and to the Republic for which it starves,
one nation unearthly God, indomitable,
with Liberty and Justice for allusion.

★

Hype led y'all gents to love lag
of the Ewe-Knighted Stakes of a Miracle.
and to the Free Pub Liquor for twitching hands,
one nay shun underdog, sing the visible,
with Libber Tea and Juiced Tits for all.

★

Belligerent poisonous race relations
electrocuted fatalistic radiation
woeful dim-witted depleted childish
ninny heathen junta thief
bravado floggings fib shat.

★

Hopeful radiant highest dawn
fleet-footed potent altruist ideal
honest brainy wise adoring
the merciful the just beatific salvation
angelic reconciling died bold.

Willie Cole's art transforms familiar everyday objects — shoes, flags, ironing boards — into unexpected new forms that comment on family, faith, national origin, and the role of work in our lives. The formal constraints Peter Pereira uses in his poetry — anagrams, palindromes, transliteration, word lists, and word substitution — similarly transform the meanings of familiar words. For instance, "The Feel of Felt" employs several anagrams or near anagrams for its lines. "High-Heeled Shoes" is written using a restricted alphabet of only those letters: HIGHHEELEDSHOES. The poem series "The Pile of Glad Elegance" uses several types of constraints — long anagram, noun substitution, verb/modifier substitution, transliteration, word list — for its exploration of The Pledge of Allegiance.

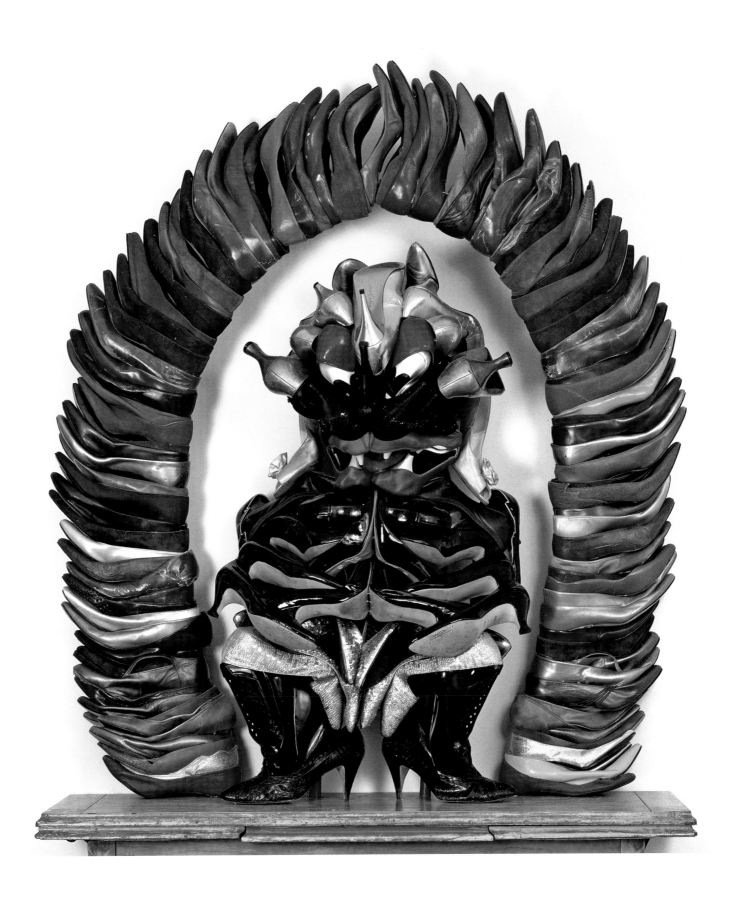

TIM EITEL

Leerer Raum (*Empty Room*), 2004. Oil and acrylic on canvas.
35½ x 27 ½ inches. Rubell Family Collection, Miami.

RYAN BOUDINOT

"If I see another onesie with a skull and crossbones on it, I'm going to puke," Nell said.

Gerhard nodded, "Onesies have evolved into a method of discourse," he said. "We buy onesies with Anarchy symbols on them to inure ourselves to the terror of parenthood."

"The worst onesie I've seen recently — I really couldn't believe it — said *Future Porn Star*."

"Oh my god, you're kidding."

"It was a pink onesie with the message in a sort of courier font. It would have probably fit a one-year-old. Child abuse, basically."

"That's the most offensive thing I've heard in a long time. That makes me want to vomit," Gerhard said. Worse, it made him feel he might be starting to become more conservative.

They took turns pushing the stroller along the irregular sidewalk beneath the Brooklyn Bridge.

They came to some windows covered in posters for a slasher movie.

"What happened to that cafe that used to be here?" Gerhard said.

The cafe had gone out of business, obviously. Condos had coagulated around the spot where the cafe used to bleed its patrons onto the sidewalk. Gerhard and Nell lived in such a condo in Dumbo a few blocks away, despite the disdain for gentrification that was a strand of their DNA. Gerhard made an analogy one night, comparing himself and Nell to Jews who ran the day to day business of concentration camps. Likewise they were hipsters luring more hipsters to their bourgeois deaths. When Nell scolded her partner for being tasteless, Gerhard reminded her that she had once painted a picture of Rudy Guiliani in an SS officer's uniform. Ah, those political battles of the nineties existed in such a snow globe of happy irrelevance. Shake it up and watch the little flurries. Remember when everyone was running around going nuts over the president's penis? Good times, good times.

The baby, Franny, fussed in her stroller, and Nell pounced, scooping up the five-week-old, holding her to her shoulder, bouncing and shushing, going all diagnostic on the diaper.

"Does she need to eat?" Gerhard said.

"I just fed her."

"Maybe she needs to burp."

Figuring out what a baby needed should have been less complicated than figuring out what was wrong with a stalled car. Just refer to the rock-bottom level of Maslow's hierarchy and you're pretty much set. And yet Gerhard and Nell found

it endlessly complicated when Franny cried, as though they'd stepped into one of those thrillers where Gene Hackman yells at people. Nell wished Gene Hackman would appear one night when Franny was waking up every half hour with hair-curling screams. Gene, she imagined, would be much more take-charge about the situation than Gerhard, who would emerge from the living room bleary-eyed from grading papers to say, "Has she eaten? Should I rock her? Does she need a diaper change?" Typically Nell would thrust the baby at him then plop face down on her pillow and cry. Gene Hackman, though, he'd stand in the doorway with his hands on his hips, yelling, "Get that baby on your nipple and make sure she stays latched! And Gerhard, I don't want to hear any guff out of you!"

How in the hell had she ever thought getting pregnant was a good idea?

Of course there were the other moments on the parenting teeter-totter, when Nell and Gerhard hovered over Franny's naked body, struck dumb at how her eyes seemed to sponge up their faces, how her skin felt composed of light, feathers, and silk. At five weeks she was starting to look like how she might look the rest of her life, in possession of Nell's dark black hair and Gerhard's chin. They leaned in close. "Are you a ballerina?" Gerhard asked, "Are you an astrophysicist? A zookeeper? A rock star?"

Now, though, on the sidewalk outside what used to be a cool place to get coffee, Franny was a screaming infant. Nell and Gerhard just wanted to get to the show. *That's all, God. Just let us look at some art this afternoon, please?* They'd missed the opening — diaper rash, acid reflux — but the show's postcard remained trapped under a magnet on their fridge, challenging them to remain hip.

Nell sat down on the edge of the sidewalk and pulled aside the top of her dress to nurse.

"Jesus, Nell. On the sidewalk?"

"Where the hell else am I supposed to nurse? It was your stupid idea to come out here," Nell said, then cooed, "Come on, little flower, let's have some milk."

There wasn't much traffic on this side street at this time of day anyway. Gerhard sat down beside his partner and rested his elbows on his knees. He imagined they were refugees, a family unit displaced under a bridge, albeit wearing really fantastic jeans. Or he imagined himself running into one of those fake tunnels Wile E. Coyote paints on the side of a mountain to fool Road Runner. There goes Road Runner, miraculously disappearing into the trompe l'oeil. And here was Gerhard, imagining this, sprinting into the tunnel, only to be smacked flat by the uncool stream train of fatherhood. He used to be so good at spelunking the Zeitgeist, discovering underground bands, amassing a DVD collection of Eastern European animators who made stop-motion films with raw meat. When he pined for a hipness slipping out of his reach, he reminded himself of what could have been had he stayed in Berlin, had the wall never crumbled, had he been contained within the barrier's paranoia and ennui rather than bursting through at precisely

the right moment, in the full hormonal OD of his adolescence. He would have never gone to graduate school, never met Nell, this bony girl from Indiana who prepared for him the most wondrous teas and painted demonic flowers on his guitar. He would never have become American. He would have never watched the towers fall or this little girl emerge crying into the world.

A musician named Zak approached on the sidewalk. Gerhard recognized him first. Zak spotted the couple and the baby, did a little double take, and appeared to debate whether to acknowledge them. But he'd made eye contact with Gerhard so he pretty much had to stop and say hi. Zak had recently styled his hair in a mohawk that flopped to the side of his head, as though it was observing a day of rest. Other external signifiers included a nose ring and a T-shirt with a picture of Barry Manilow on it. He wore a mustache that seemed to proclaim, "Hey, look, everybody, I grew a mustache!" He smiled.

"Hey Zak," Gerhard said.

"Oh, hey guys. This is your baby?"

Franny had decided to quit nursing and had come disattached from Nell's boob, now spurting a couple streams of milk. She tucked it back into her bra. Then, somewhat perfectly, Franny loudly filled her diaper.

"This is the baby," Gerhard said.

Zak knelt and squinted at the human specimen. "She's so small."

"They come out of the vagina easier that way," Nell said.

Zak laughed.

"Man, we haven't seen you in forever," Gerhard said, "What's going on with your music?"

"Lots, man. We just signed with Matador. We're the openers for Clap Your Hands Say Yeah on their East Coast leg. Insane. Jerry our drummer went and broke his arm doing parkour. So we're quickly trying to get a replacement guy up to speed. Oh my god, what's that? Is she okay?"

Franny had spit up. A river of chunky breast milk ran down Nell's arm. Gerhard grabbed a wipe out of the diaper bag and took care of it.

"We were trying to get to a show. We had to make a stop here to refuel the baby," Gerhard said. "You don't know of a place close by where we could change her do you?"

"You can come up to my place. I live in this building," Zak said, glancing up at the condos. In the chess game of hipness Zak had just revealed a vulnerability. Gerhard felt, if not vindicated exactly, somewhat less lame. Zak lived on the tenth floor. The three of them and the stroller barely fit in the elevator. The condo seemed more a place for storing digital media than a home. Outside the window loomed Manhattan, raw material of ambition and antidote to dreams. Gerhard found a chair and laid out the diaper, wipes, and ointment. Zak put on a kettle of water to boil and set up a French press. Nell sat on the floor next to a pile of the issue of *Black Book* in which Zak had modeled. Gerhard stashed Franny's poopy

diaper in a *New York Times* bag and stuffed it into the diaper bag. Franny wanted to eat again. Gerhard handed her to Nell.

"I was thinking about you guys the other day," Zak said, "What's up besides the baby?"

"I'm taking four months off from work," Nell said, "I thought I'd get some painting done, but it's just nurse, diaper, nap, nurse, diaper, nap, all day long."

"You look like you haven't slept much," Zak said.

"Yeah. I'm looking forward to that coffee," Gerhard said. "The lack of sleep is crazy. Like how is it evolutionarily beneficial to make the parents of this fragile new creature insane from sleep deprivation?"

Franny nursed awhile then let out a satisfied grunt, full of milk. The room filled with free-trade coffee aroma.

"I don't think I've ever held a baby," Zak said.

"Would you like to?" Nell said, "You can."

"You sure?" Zak said, sitting down on the floor. Nell moved his arms to where they needed to be then placed the baby in them.

"Make sure you support the head," Nell said. "There you go."

"She's heavier than she looks. Wow. This is amazing."

Franny's eyes fluttered then closed to sleep.

"She likes you, dude. You're lucky you got her to sleep," Gerhard said.

"What a beautiful girl," Zak said.

"Sing to her," Nell said.

"*Ziggy played guitar, jamming good with Weird and Gilly,*" Zak sang.

Gerhard laid down on the floor and closed his eyes, using an anthology of articles from *Cahiers du Cinema* as a pillow. Zak was doing it, wasn't he, latching on to a kind of artistic freedom that had always seemed just out of reach for Gerhard and Nell. Gerhard was prepared to hate Zak for his success, but lying on the floor with his head supported by a decade of French film criticism, he told himself, *Let it go, dude.* Leave those petty bohemian resentments behind. You're responsible for bringing more love into this world for your little girl.

Zak held the baby until the water started to boil. "Thanks for letting me hold her. She's gorgeous," he said, gently handing the baby back to Nell. He prepared the coffee and cut up some apples he'd bought at a farmers' market. They talked about the status of various acquaintances, the absence of time and money, projects they hoped to take on. In the presence of the baby the old friends became less representatives of ideas than individuals picking up ideas, toying with them, tossing them aside. When the coffee mugs were empty and Franny was asleep in her stroller, Nell and Gerhard rose from the floor and hugged their friend, thanking him for allowing them to use his place as a rest stop. Zak wished them peace and good luck, and gave them a flier for his forthcoming album.

Back on the street the new family progressed a couple more blocks and came to the gallery. Gerhard lifted the stroller over the front step and pushed it inside.

They stood a moment in the airy space trying to get their bearings.

"The show is over," Nell said. For a moment Gerhard thought she might be laying down some sort of metaphor. But it was true. The walls were bare. They must've not noticed the dates printed on the postcard. Nonetheless they stood quietly and waited, as if in the presence of art.

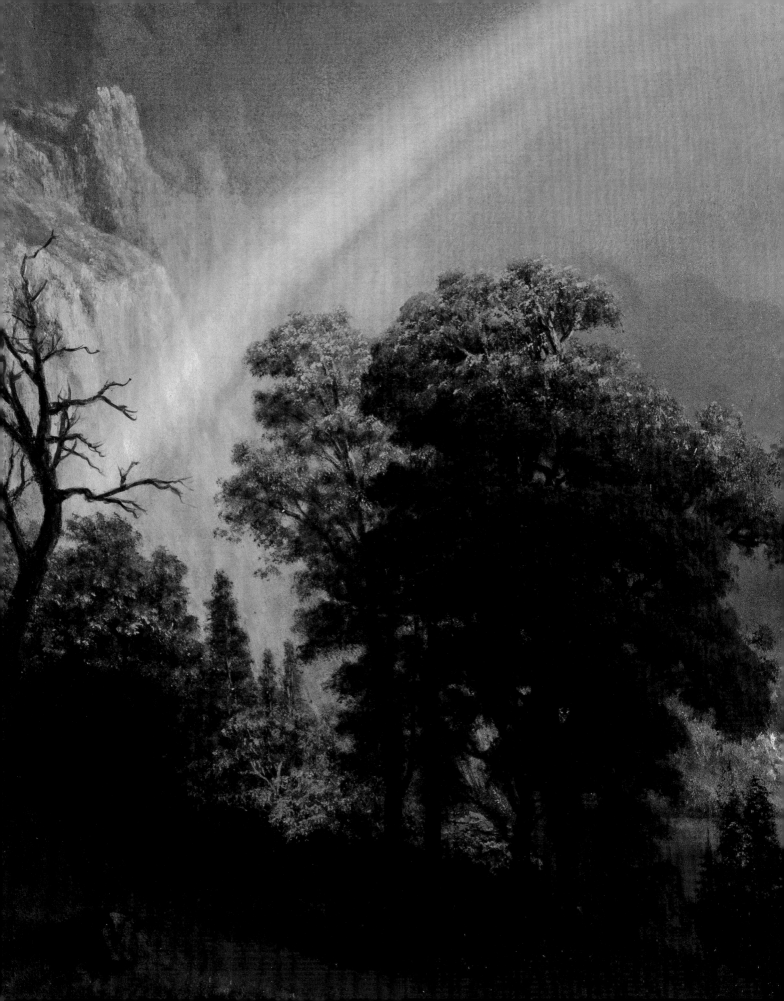

WORKS OF ART

All works of art reproduced in this book are in the collections of the Frye Art Museum, Seattle, Washington, except as noted.

Albert Bierstadt. *Rainbow in the Sierra Nevada*, c. 1871–73. Oil on panel. 18 x 24 inches. Frye Art Museum purchase, 1997. Photograph by Susan Dirk.

Willie Cole. *Sole Protector*, 2005. Shoes, PVC pipe, painted wood table, metal, and screws. 80¼ x 44 x 15¾ inches. Courtesy of Alexander and Bonin, New York.

Henry Darger. Untitled (Battle scene during lightning storm. Naked Children with Rifles), mid-twentieth century. Watercolor, pencil, and carbon tracing on pieced paper. 24 x 74¾ inches. Collection American Folk Art Museum, New York, gift of Nathan and Kiyoko Lerner, 1995.23.1b. © Kiyoko Lerner. Photo by Gavin Ashworth.

Tim Eitel. *Leerer Raum (Empty Room)*, 2004. Oil and acrylic on canvas. 35½ x 27 ½ inches. Rubell Family Collection, Miami.

Victoria Haven. Altar for *Sin*, 2007. Mylar, polypropylene paper, and pins. Courtesy of the artist and Greg Kucera Gallery, Seattle. Photo: Paul Macapia.

Gabriel von Max. *The Christian Martyr*, 1867. Oil on paper affixed to canvas. 48 x 36¾ inches. Charles and Emma Frye Collection.

Robyn O'Neil. *As my heart quiets and my body dies, take me gently through your troubled sky*, 2005. Graphite on paper (5 framed panels). Overall: 165 x 59 inches. Collection of Nancy and Tim Hanley and fractional gift of Mr. and Mrs. Hanley to the Dallas Museum of Art.

Patricia Piccinini. *The Embrace*, 2005. Silicone, fiberglass, leather, plywood, clothing, and human hair. Dimensions variable. © Patricia Piccinini. Courtesy of the artist and Yvon Lambert New York.

Dario Robleto. *A Century of November*, 2005. Child's mourning dress made with homemade paper (pulp made from sweetheart letters written by soldiers who did not return from various wars, ink retrieved from letters, sepia, bone dust from every bone in the body), carved bone buttons, hair flowers braided by a Civil War widow, mourning dress fabric and lace, silk, velvet, ribbon, World War II surgical suture thread, mahogany, glass. 38 x 38 inches. Collection of Stanley and Nancy Singer, East Hampton, New York.

Sigrid Sandström. *Ginnungagap*, 2004. Acrylic on polycarbonate. 48 x 72 inches. Courtesy of the artist and Inman Gallery, Houston.

Franz von Stuck. *Sin (Die Sünde)*, c. 1908. Syntonos on canvas. 34⅞ x 21⅝ inches. Charles and Emma Frye Collection.

John Henry Twachtman. *Dunes Back of Coney Island*, c. 1880. Oil on canvas. 13⅞ x 20 inches. Frye Art Museum Purchase, 1956.

Pieter van Veen. *First Snow*, 1914. Oil on canvas. 15 x 21³⁄₁₆ inches. Charles and Emma Frye Collection.

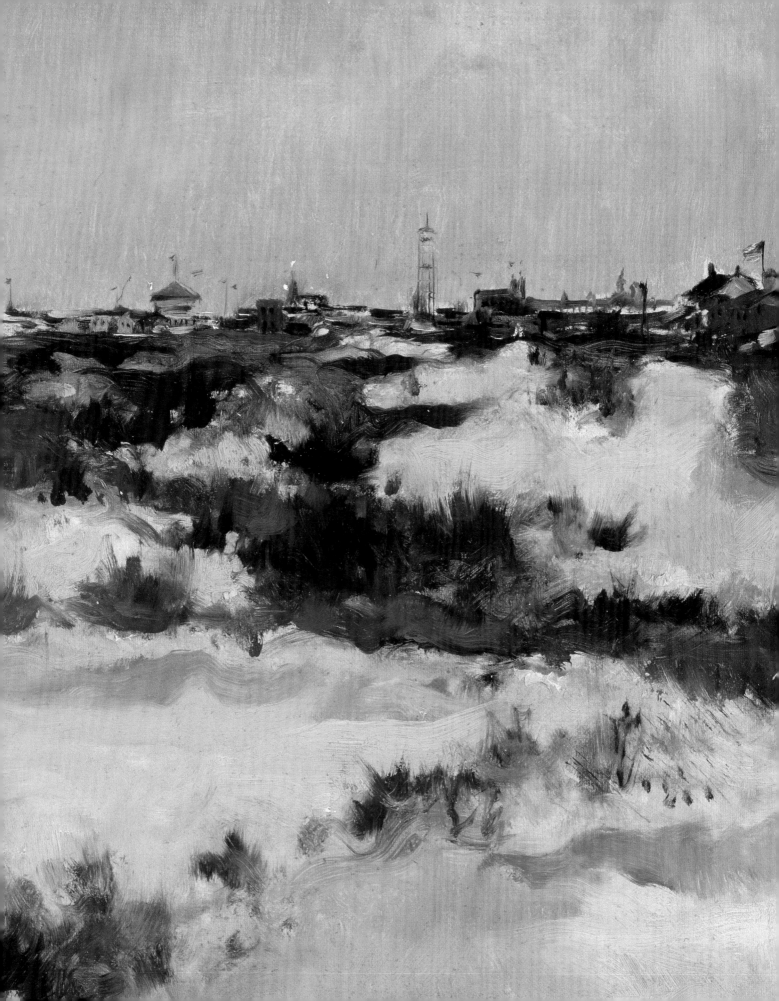

ARTISTS

ALBERT BIERSTADT (1830–1902) was born in Solingen, Germany, and brought to New Bedford, Massachusetts, when he was two years old. In 1854, he returned to Germany to study at the Düsseldorf Art Academy. After a brief period of activity in the White Mountains, Bierstadt joined Colonel Frederick Lander on an expedition to survey a wagon route to the Pacific. The painter's romantic depictions of the American West brought him immediate attention, solidifying his status as one of the most distinctive artists of the Hudson River School. Bierstadt's painting *Rainbow in the Sierra Nevada* (c. 1871–73) is part of the Frye Collections.

Born in Somerville, New Jersey, in 1955, **WILLIE COLE** received a BFA from the School of Visual Arts, New York, in 1976. He has resided and worked in Newark, New Jersey, and he now lives with his family in Mine Hill, New Jersey. The artist's work is in numerous private and public collections, and he is represented by Alexander and Bonin, New York. The exhibition Anxious Objects: Willie Cole's Favorite Brands was on view at the Frye Art Museum June 23–September 3, 2007.

HENRY DARGER (1892–1973) is best known for his fifteen-thousand-page illustrated epic, *The Story of the Vivian Girls, in What is Known as the Realms of the Unreal, of the Glandeco-Angelinnian War Storm, Caused by the Child Slave Rebellion*. A self-taught artist and recluse, Darger created an extensive body of writings, paintings, and drawings during his lifetime. As Darger's work has become better known to both outsider-art and contemporary-art audiences, it has won wide acclaim from critics, art historians, curators, and collectors who have recognized Darger as one of the most original talents of his time. The exhibition Henry Darger: Highlights from the American Folk Art Museum was on view at the Frye Art Museum August 19–October 29, 2006.

TIM EITEL, born in 1971 in Leonberg, Germany, studied at the University of Stuttgart, the Burg Giebichtenstein, and the Hochschule für Grafik und Buchkunst in Leipzig, pursuing his graduate studies under Arno Rink. Solo exhibitions of Eitel's work have been organized by the St. Louis Art Museum, Missouri; Museum zu Allerheiligen-Schaffhausen, Switzerland; Künstlerhaus Bethanien, Berlin; and the Kunsthalle Tübingen, Germany. Group exhibitions include those at Mass MOCA; the Cleveland Museum of Art; Museum der Bildenden Künste, Leipzig; and Frankfurter Kunstverein. Tim Eitel's painting *Leerer Raum* (*Empty Room*, 2004) was exhibited at the Frye Art Museum February 17–June 3, 2007 as part of the exhibition Life after Death: New Leipzig Paintings from the Rubell Family Collection.

Born into a well-known Bohemian family of sculptors, **GABRIEL VON MAX** (1840–1915) trained at both the Prague Academy and the Vienna Academy, before studying in Munich under Karl von Piloty. His most celebrated work, *The Martyr at the Cross*, was painted in 1867 and quickly garnered much attention. The artist opened his own atelier in 1869 and served as a professor of historical painting at the Academy of Munich. He was knighted by the Bavarian state in 1900. Several Gabriel von Max paintings are in the Frye Founding Collection. *The Christian Martyr* (1867) was recently exhibited in The Munich Secession and America, on view at the Frye Art Museum January 24–April 12, 2009. As part of the exhibition Over Julia's

Dead Body, on view at the Frye Art Museum May 2–September 13, 2009, *The Christian Martyr* will be shown accompanied by an audio recording of Lesley Hazleton reading her story "A Christian Martyr."

ROBYN O'NEIL was born in Omaha, Nebraska, in 1977 and received her BFA from Texas A&M University–Commerce in 2000. She is represented by Clementine Gallery, New York. O'Neil's work was included in the 2004 biennial at the Whitney Museum of American Art in New York and has also been seen in group exhibitions at the Dallas Museum of Art and the Arlington Museum of Art, Texas. The solo exhibition Robyn O'Neil, organized by the Contemporary Arts Museum, was on view at the Frye Art Museum April 29–July 30, 2006.

PATRICIA PICCININI, born in 1965 in Freetown, Sierra Leone, currently lives and works in Melbourne. She represented Australia in the 2003 Venice Biennale and has exhibited internationally, including solo exhibitions at the Museum of Contemporary Art, Sydney; the Hara Museum of Contemporary Art, Tokyo; and City Gallery Wellington, New Zealand. Her artwork is included in major private and public collections throughout the world. The Frye Art Museum co-organized the first U.S. survey of Piccinini's work, Hug: Recent Work of Patricia Piccinini, which was on view at the Frye Art Museum September 22–January 6, 2008.

Born in 1972, **DARIO ROBLETO** received his BFA in 1997 from the University of Texas–San Antonio. Solo exhibitions have been organized by the Weatherspoon Art Museum, University of North Carolina; the Whitney Museum of American Art at Altria; and the Contemporary Arts Museum Houston. Robleto's work has been collected by the Museum of Fine Arts, Houston; the Museum of Contemporary Art, San Diego; the Whitney Museum of American Art; and the Los Angeles County Museum of Art, among others. The exhibition Heaven Is Being a Memory to Others,

sculptural work by Robleto with paintings selected by the artist from the Frye Collections, was on view at the Frye Art Museum April 26–August 10, 2008. Dario Robleto: Alloy of Love, a ten-year survey of Robleto's work, was on view at the Frye Art Museum May 17–September 1, 2008.

SIGRID SANDSTRÖM was born in 1970 in Stockholm, Sweden. She received her MFA from Yale University. Sandström served as artist-in-residence in the Core Program at the Museum of Fine Arts Houston, and has been a recipient of an Artadia Award for emerging artists and a Guggenheim Foundation Award for research in Antarctica. Selected exhibitions include Mills College Art Museum, Massachusetts College of Art, and Edward Thorp Gallery, New York. Sandström is currently assistant professor of art at Bard College. She is represented by Inman Gallery, Houston, and Gunnar Olsson Gallery, Stockholm. The exhibition Ginnungagap: Recent Work by Sigrid Sandström was on view at the Frye Art Museum May 26–September 10, 2006. Oyster Skies: Meditations on Northern Landscapes, a projected work by Sandström with paintings selected by the artist from the Frye Collections, will be on view at the Frye Art Museum in an upcoming exhibition.

Co-founder of the Munich Secession, **FRANZ VON STUCK** (1863–1928) taught at the Munich Academy, where he widely influenced a generation of painters, including Paul Klee and Wassily Kandinsky. Born in Tettenweis, Bavaria, in 1863, Stuck trained at the Munich Academy and the Academy of Fine Arts in Munich, where he studied under Wilhelm Lindenschmit and Ludwig Löfftz. A series of his zincographs were published between 1882 and 1884 by the Viennese publishing company Gerlach and Schenk. Stuck's painting *Sin* (*Die Sünde*; c. 1908) is included in the Frye Founding Collection. For the exhibition Sin, on view at the Frye Art Museum March 17–October 14, 2007, the painting was installed in a Mylar altar created by Seattle artist Victoria Haven. *Sin* was recently

exhibited in The Munich Secession and America at the Frye Art Museum January 24–April 12, 2009.

Trained at the Munich Royal Academy and the Académie Julian in Paris, landscape painter **JOHN HENRY TWACHTMAN** (1853–1902) was at the forefront of the American avant-garde throughout his career. In 1897, Twachtman helped to found the Ten American Painters, a group of primarily Impressionist painters who broke from the Society of American Artists. He taught at the Art Students League in New York through the 1890s. Twachtman's painting *Dunes Back of Coney Island* (c. 1880) is included in the Frye Collections.

Born in the Netherlands, **PIETER VAN VEEN** (1875–1961) trained at the Royal Academy of the Arts, The Hague, before taking up residence in Barbizon, France. He mentored under Henri Harpignies and was influenced by the work of Renoir, Monet, and Cézanne. The artist emigrated to America in 1915, where he produced a notable series of French cathedral paintings that was exhibited in 1928 at the National Gallery of Art in Washington DC. The French government awarded van Veen the Chevalier de la Legion d'Honneur. Van Veen's painting *First Snow* (1914) is part of the Frye Founding Collection and will be exhibited in Oyster Skies: Meditations on Northern Landscapes at the Frye Art Museum.

WRITERS

RYAN BOUDINOT is the author of *The Littlest Hitler* (Counterpoint Press, 2006), a collection of short stories. His first novel will be published by Grove Press in fall 2009. His work has appeared in *McSweeney's*, *The Best American Nonrequired Reading*, and *The Stranger*. Boudinot teaches at Goddard College's MFA program in Port Townsend, Washington, and lives in Seattle.

CHRISTINE DEAVEL is co-owner of Open Books, a poetry-only bookstore in Seattle. Her chapbook *Box of Little Spruce* was published by LitRag Press in 2005. Her work has appeared in *American Letters & Commentary*, *Fence*, *Golden Handcuffs*, *Volt*, and other magazines. She is a graduate of Indiana University and of the Iowa Writers' Workshop.

ADRIANNE HARUN is the author of *The King of Limbo* (Houghton Mifflin, 2002), a Sewanee Writers' Series selection and a Washington State Book Award finalist. Her fiction and essays have appeared in numerous magazines, have won awards from *Story* and the *Chicago Tribune*, and have been noted in *Best American Mystery Stories*. A longtime resident of Port

Townsend, Washington, Harun teaches in Pacific Lutheran University's MFA program Rainier Writing Workshop.

LESLEY HAZLETON lived in Jerusalem for thirteen years and has written on Middle East politics for the *New York Times*, *Esquire*, *Vanity Fair*, *The Nation*, and many other publications. Her award-winning books include *Mary: A Flesh-and-Blood Biography of the Virgin Mother* (Bloomsbury, 2004) and *Jezebel: The Untold Story of the Bible's Harlot Queen* (Doubleday, 2007). Her new book, *Karbala: The Enduring Saga of the Sunni-Shia Split* (working title), is due from Doubleday in fall 2009. British-born, Hazleton lives and writes in a houseboat in Seattle, her home since 1992.

RICHARD HUGO was an eminent American poet and essayist who lived in the Northwest, worked at Boeing, and later became the director of the creative writing program at the University of Montana. His books include *Making Certain It Goes On: The Collected Poems of Richard Hugo* (Norton, 1984); *The Real West Marginal Way: A Poet's Autobiography* (Norton, 1986);

The Triggering Town: Lectures and Essays on Poetry and Writing (Norton, 1979); and a mystery novel, *Death and the Good Life* (St. Martin's, 1981). Hugo received the Theodore Roethke Memorial Prize and was twice nominated for the National Book Award. He died in 1982.

STACEY LEVINE is the author of two story collections, *My Horse and Other Stories* (Sun and Moon Press, 1994), winner of the PEN/West Fiction Award, and *The Girl with Brown Fur* (MacAdam Cage, 2009), as well as the novels *Dra —* (Sun and Moon Press, 1997) and *Frances Johnson* (Clear Cut Press, 2005), which was a finalist for the Washington State Book Award. She also wrote the libretto for an opera based on battles between the Pacific Northwest Quileute tribes and Russian traders. She has contributed to the *American Book Review*, *Bookforum*, and the *Seattle Post-Intelligencer*. She lives in Seattle.

FRANCES MCCUE is a Seattle-based poet, essayist, journalist, educator, and consultant to writers, writing programs, and nonprofits. She is the writer-in-residence at the University of Washington's Undergraduate Honors Program. Her first book, *The Stenographer's Breakfast*, was a collection of poems from Beacon Press. From 1996 to 2006, she was the founding director of Richard Hugo House. *The Northwest Towns of Richard Hugo* is forthcoming from the University of Washington Press, as is her memoir, *Chasing Richard Hugo*. During 2008 and 2009, McCue is in Marrakesh, Morroco, on a Fulbright Fellowship, with her daughter, Madeleine, and husband, Gary.

MELINDA MUELLER grew up in Montana and eastern Washington and has lived in Seattle for thirty years. She majored in botany at the University of Washington, where she also studied poetry with Nelson Bentley. Her most recent book, *What the Ice Gets* (Van West & Company, Publishers, 2001), recounting in the form of an epic poem Ernest Shackleton's final attempt to reach the South Pole, received a Wash-

ington State Book Award as well as a Notable Book Award from the American Library Association. She teaches high-school biology, biotechnology, and evolution studies at Seattle Academy.

JACK NISBET is the author of *Sources of the River: Tracking David Thompson across Western North America* (Sasquatch Books, 1994), which received the Murray Morgan Prize; *Purple Flat Top* (Sasquatch Books, 1996); *Singing Grass, Burning Sage* (Graphic Arts, 1999); *Visible Bones* (Sasquatch Books, 2003), which won a Washington State Library Award; and *The Mapmaker's Eye: David Thompson on the Columbia Plateau* (Washington State University, 2005). Nisbet's forthcoming book, *The Collector: David Douglas and the Naming of the Pacific Northwest*, will be published by Sasquatch Books in fall 2009. He lives in Spokane with his family.

PETER PEREIRA is a family physician in Seattle and founding editor of Floating Bridge Press. Pereira is the author of three collections of poetry, including *The Lost Twin* (Grey Spider, 2000), *Saying the World* (Copper Canyon Press, 2003), and *What's Written on the Body* (Copper Canyon Press, 2007), which was a finalist for the Washington State Book Award. He is a winner of a 1997 Discovery/The Nation Award and is featured in the 2007 *Best American Poetry* (Scribner).

JONATHAN RABAN is a British writer who moved from London to Seattle in 1990. His travel books and novels include *Soft City* (Harvil Press, 1998), *Bad Land* (Picador, 1996), *Passage to Juneau* (Picador, 1999), *Hunting Mister Heartbreak* (Edward Burlingame Books, 1990), and *Surveillance* (Pantheon, 2006). His awards include the National Book Critics Circle Award, the Heinemann Award for Literature, and the Thomas Cook Award, among others. Raban contributes regularly to several newspapers and magazines, including the *Guardian* and the *New York Review of Books*.

REBECCA BROWN is the author of *American Romances*, a collection of essays due from City Lights Books in spring 2009. Her titles published in the United States and abroad include *The End of Youth* (City Lights Books, 2003), *The Last Time I Saw You* (City Lights Books, 2006), *The Gifts of the Body* (HarperCollins, 1994), and *Woman in Ill-Fitting Wig* (Pistil Books, 2005), the latter a series of prose poems accompanying paintings by Nancy Kiefer. A frequent collaborator, Brown has also written texts for dance, stage, and opera. Brown lives in Seattle and teaches at Goddard College in Vermont.

MARY JANE KNECHT is manager of adult programs and publications at the Frye Art Museum, where she develops interdisciplinary programs and publications related to the Frye Collections and exhibitions. Prior to joining the Frye in 2004, Knecht worked in literary publishing and programming with Copper Canyon Press; Seattle Arts & Lectures; Van West & Company, Publishers; and other Pacific Northwest nonprofit arts organizations. Knecht divides her time between Seattle and Chimacum, Washington.

ACKNOWLEDGMENTS

This book represents the collective efforts of many individuals, including participating writers and artists, lending collectors and institutions, and staff of the Frye Art Museum and University of Washington Press.

A special thanks to the Frye staff who helped in a wide variety of ways to make this publication possible: Midge Bowman, executive director; Rebecca Garrity-Putnam, director of communications; Robin Held, chief curator and director of collections and exhibitions; Donna Kovalenko, curator of collections; Laura Landau, curatorial manager; Annabelle Larner, exhibitions registrar; and, especially, Jill Rullkoetter, deputy director and director of education and visitor experience. Our appreciation goes to Shin Yu Pai for her editorial skills at critical moments.

Collaborating with the University of Washington Press has been a rich partnership. We are grateful to Pat Soden, director, for his unflinching support during all phases of this project. Special thanks to Rachel Mann, publicist; Mary Ribesky, assistant managing editor; Ashley Saleeba, senior designer; and Julie Van Pelt, ace copyeditor.

To the writers and artists, our gratitude for teaching us to see in new ways.

REBECCA BROWN & MARY JANE KNECHT
Co-Editors